T0277203

ESSEX'S MILITARY HERITAGE

Adam Culling

AMBERLEY

About the Author

Adam Culling is a museum curator and historian who has had a lifetime interest in military history. He has had the privilege to curate many regimental and local history museum collections, and has edited the books *Fighting Fit 1914* (Amberley Publishing, 2014) and *Fighting Fit 1939* (Amberley Publishing, 2014). He lives on the Essex–Suffolk border with his wife and young daughter. His other interests include trail running, cycling on roads and trails, and rating the Sunday roasts at local pubs.

First published 2023

Amberley Publishing
The Hill, Stroud
Gloucestershire, GL5 4EP

www.amberley-books.com

Copyright © Adam Culling, 2023

Logo source material courtesy of Gerry van Tonder

The right of Adam Culling to be identified as the Author of this work has been asserted in accordance with the Copyrights, Designs and Patents Act 1988.

ISBN 978 1 3981 0307 8 (print)
ISBN 978 1 3981 0308 5 (ebook)

British Library Cataloguing in Publication Data.
A catalogue record for this book is available from the British Library.

Origination by Amberley Publishing.
Printed in Great Britain.

Contents

Introduction

Whether you are a passing visitor or a long-term resident, after a short journey through Essex it soon becomes apparent why the county has such a rich and varied military heritage. Essex's lengthy and convenient coastline has made it an appealing target for Roman, Saxon, Viking and French invasions, and the various rivers and fertile land provide an excellent opportunity for resupply, foreign trade and local commerce. Its proximity to London at time of conflict has resulted in Essex being intentionally (and accidentally) targeted by the enemy from the skies, and its flat terrain has made it an ideal location for invading forces to rapidly move inland to the country's capital and heartlands.

It is for these reasons that readers can explore over 2,000 years of military heritage in Essex, beginning with the Roman invasion and subsequent Iceni uprising at modern-day Colchester, continuing today with the modern military garrisons and barracks, military museums and other heritage sites. Foreign and domestic conflicts have all had a lasting impact on Essex's landscape. Airfields, munition factories, memorials, barracks, castles and other fortified positions are scattered across the entire county. Some are derelict; their unassuming appearance tells little of their fascinating stories. Others are perfectly preserved and have been interpreted for generations to come. Essex-born and honorary Essex men and women – those who served or fought in the county, served overseas, carried out gallant deeds and those who simply did their bit – all played an important role in shaping Essex's military heritage.

While this books aims to represent the military contribution made by the entire county of Essex, within the ancient and current boundaries, some areas are represented less than others. This is partially due to the length of this book, but also due to my own particular interest in certain geographical areas, historical periods, and specific military events. I do, however, hope that this book offers an insight to the breadth and depth of Essex's military heritage, and that it inspires readers to research their own areas of military heritage, whether in Essex or elsewhere.

1. Invasion and Conquest

In the summer of 55 BC, a Roman force led by Julius Caesar first invaded Britain and set in motion a series of subsequent Roman invasions that would lead to one of the most notorious battles in Essex's, and Britain's, history. A potted history of the events that led to this battle follows.

The small Roman force that landed in Kent in 55 BC and after developing relationships with the of the Trinovantes and the tribes of the east, left Britain the following September. The Romans were provoked to invade again in AD 43 when the Catuvellauni tribe (who were leaders in tribal resistance against the Romans) annexed Roman territories in Kent. The Romans were victorious in the battles of the River Medway and Thames, and in late summer AD 43 the former principal settlement of the Trinovantes, now a Catuvellauni stronghold, Camulodunum (modern-day Colchester), was captured.

At first Camulodunum was fortified at its highest point and the Roman army's Legio XX, who took part of the invasion of Britain, built and occupied the fortress. By AD 49, as Roman influence in Britain spread, the fortress had been decommissioned and converted into a civilian settlement. It was named Colonia Claudia after the emperor and became the first capital of the Roman province Britannia. Many of the military barracks and buildings were repurposed for civilian use, and the large legionary defences were removed. Within ten years of its foundation, Colonia Claudius would be destroyed in one of Essex's, and Briton's, most iconic revolts and by one of its earliest heroines. When the king of the Iceni died in AD 59, half of the wealth of his kingdom was left to his queen, Boudicca, and their two daughters, and half to the local Roman leaders. While this arrangement had worked in the past, the current Roman commanders refused to recognise women to be the Iceni kings' heirs. When Boudicca failed to accept this, she and her daughters were assaulted, which provided the catalyst for Boudicca and the Iceni to revolt against the Romans. In AD 60, the Iceni and Trinovantes combined their forces to attack the now relatively unprotected Camulodunum, where those who survived the initial attacks retreated to the Temple of Claudius.

The temple was the largest building in the Colonia, and was now the physical and symbolic focus of the Britons' fury: having been paid for by local taxes and built using Briton slave labour, it was destroyed by fire and its defenders killed. The town was rebuilt by the Romans; this time a substantial defensive wall was built between AD 65 and AD 80; however, Colchester's national status never truly recovered.

When the Anglo-Saxons arrived in Britain around AD 450 following the collapse of the Roman Empire, they travelled from present-day Germany, Denmark and Holland, with the Angles settling in East Anglia, and the Saxons in Sussex, Middlesex, Wessex and parts of Essex. The name 'Essex' is based on the Anglo-Saxon name ☐astseaxe, or the East Saxons. In AD 892, a large Danish force of 250 ships invaded with the intention

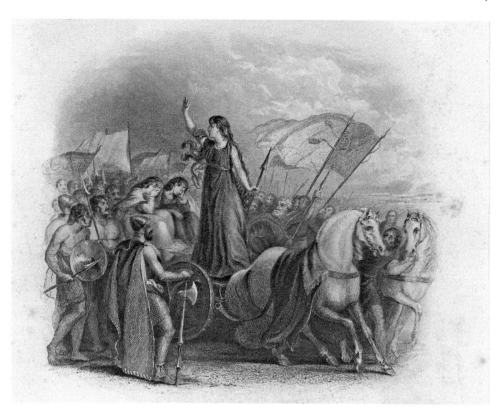

Above: Boudicca haranguing the Britons.

Right: Boudicca statue by Jonathon Clarke, erected near Colchester North railway station in 1999.

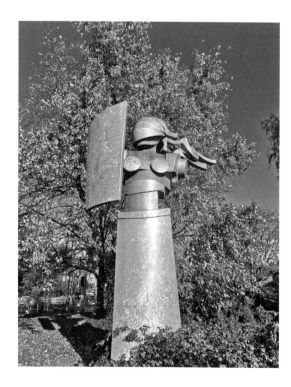

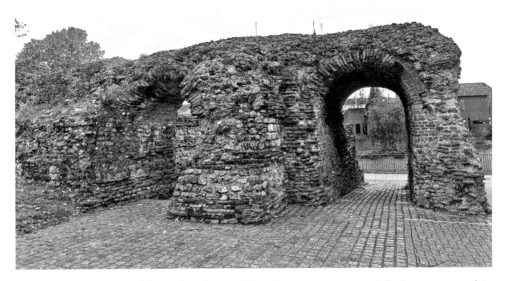

The Balkerne Gate is Colchester's only surviving Roman gateway and the best preserved in the country.

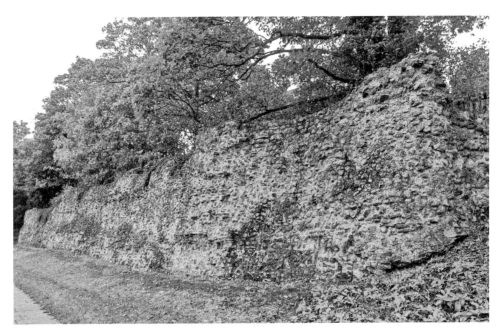

Section of Colchester's Roman wall along Balkerne Hill.

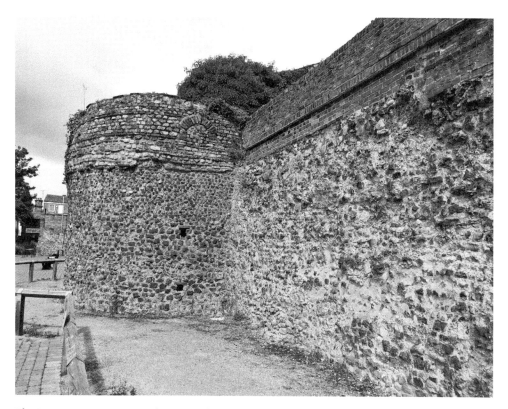

The Priory Street Bastion and section of Roman wall.

of taking control of Alfred the Great's kingdom. Alfred had been warned of the coming invasion and attacked a small Danish force, who retreated across the Thames to the Danish settlement of Beamfleote (present-day South Benfleet). Beamfleote had been established by the Danes some years prior, and its position of being surrounded by forest and two fresh water streams meant that it was hidden from the main estuary. It was the perfect place for the small Danish force to set for raids in Kent and London, and the tidal marshes provided protection from surprise attacks from the sea. Recognising that the concentration of Danish forces at Beamfleote posed a significant risk, King Alfred's army used the forest tracks along the Thames until it reached Hadleigh in Essex. From Hadleigh's high ground, the Anglo-Saxon force attacked the Danes at Beamfleote, and despite the bolstered defences the unsuspecting Danish force was soon overrun. The fort was laid to ruin, the Viking ships were burned, and surviving Danes fled to the Danelaw settlement at Shoebury.

In August AD 991, the Battle of Maldon began when Viking invaders landed their ships on an island in the Blackwater Estuary, now believed to be Northey Island, led by the infamous Olaf Tryggvason. The battle was a disaster for Ealdorman Byrhtnoth and his Anglo-Saxon force: the Viking invaders were effectively trapped on Northey Island, so Tryggvason asked that his forces be allowed to cross over to the mainland and fight on equal terms. Byrhtnoth agreed, accepting that his refusal could result in the Danes

Left and below: Stone and iron sculptures commemorating the Battle of Benfleet, installed 2007 and 2008 respectively.

Raised earthworks at Shoebury, believed to be part of the Danish camp.

boarding their ships and attacking unprotected settlements elsewhere, so the battle took place on the mainland across from Northy Island. The Viking forces, although estimated to be outnumbered by the Anglo-Saxons two-to-one, proved to be too much for Byrhnoth's army, who fell in battle alongside much of the Anglo-Saxon nobility. Although a Viking victory, they too suffered severe losses, which affected their ability to continue attacking further inland. This defeat ultimately marked the beginning of the end of Anglo-Saxon rule in Britain.

One of the final Anglo-Saxon battles against the Vikings in Essex was in October AD 1016. The Battle of Assandun, believed to have been fought at Ashingdon near Rochford, was fought between the Danish King Cnut and King Edmund Ironside. Cnut's army was challenged by the forces of King Edmund in Kent and was forced to retreat to Essex. In Essex, King Edmund was joined by forces under command of Eadric Streona, Ealdorman of Mercia. The battle was fought on Ashingdon Hill, and Cnut won a bloody victory, albeit with heavy losses on both sides, after Streona betrayed the King Edmund and left the battlefield. The result of the battle was that Edmund would be king of Wessex, and Cnut the king of Danelaw territory, the area north of the Thames. It was agreed that whoever outlived the other would inherit their kingdom, and their son be heir to the throne. On 30 November AD 1016, only six weeks after the Battle of Assandun, King Edmund died, leaving Cnut as king of England. Although the Anglo-Saxon rule of England wasn't at its end, within fifty years neither Saxon nor Viking forces would be the dominate force in England.

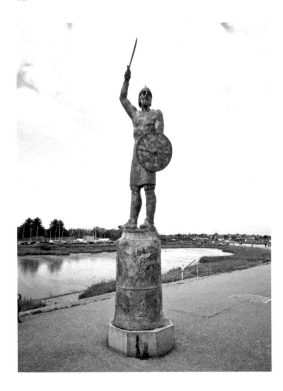

Statue of Byrhtnoth at the end of
the Maldon Promenade Walk that
commemorates the Battle of Maldon.

In 1035, King Cnut of Demark and England died. His sons, Harold Harefoot and
Harthacnut, ruled for the next seven years between them but left no heirs. Danish rule
in England had effectively ended, which allowed a Saxon king to rule once more. Edward
the Confessor, son of Æthelræd, restored the House of Wessex when he became king of
England in 1042. His death in January 1066 led his son, Harold Godwinson, to become
king in January 1066 until his legendary death at the Battle of Hastings in October 1066.
The Bayeux Tapestry depicts Harold being struck by an arrow in the eye, and it is believed
that Harold's remains were transported and buried at Waltham Abbey.

Although Essex had a minor role in the story of Norman invasion, the legacy of the
Norman Conquest is another matter entirely. Some of the finest examples of stone-built
Norman castles can be found in Essex. However, Essex isn't an area known for its stone,
a problem faced by the Romans when building Colchester's defensive walls. The majority
of Norman castles built in Essex were made of earth and timber, and followed one of
two forms – motte or ringwork. Norman earth and timber castles built in Essex include
Rayleigh, Great Canfield, Ongar, Stebbing, Stansted Mountfitchet, Pleshey and Mount
Bures. Rayleigh and Pleshey are excellent examples of the classic motte-and-bailey design,
with a kidney-shaped bailey wrapped around the motte. Stansted Mountfitchet Castle
was built in the ringwork design; however this example also included a bailey and would
later include a stone structure.

It is in Essex where arguably the largest, most iconic and visually dramatic Norman
castle was built. Colchester Castle, one of the earliest stone castles, was built because of
the town's position on the strategic route between East Anglia and London. Construction

What is believed to be the burial place of King Harold at Waltham Abbey.

The mount of Pleshey Castle, connected by a fourteenth-century stone bridge.

began in 1076 and is believed to be the design of Gundulf, Bishop of Rochester (famous for building the White Tower in London, though Colchester has a larger keep). The castle was built over the ruined Roman Temple of Claudius, the base of the temple being incorporated into the keep's foundations. The threat of a Danish invasion in 1085 temporarily halted construction, with only the first floor of the castle built with temporary corner turrets and battlements. It wouldn't be until *c.* 1100 that worked continued on Colchester Castle, and although now only standing two storeys tall, it was built to an imposing four storeys high.

The second significant stone Norman castle is in the Essex village whose name is derived from the imposing Norman fortress: Castle Hedingham. Hedingham Castle is one of the finest preserved four-storey Norman keeps in England, built in around 1140 by Aubrey De Vere II, it stands over 110 feet high and with walls over 12 feet thick at the base and 10 feet at the top. Colchester would be the only Norman castle built to provide protection from foreign enemies; most Norman castles, including the one at Hedginham, were built as a symbol of Norman power, offering protection from the local population who found themselves under new and often unwelcomed patronage. As a result, many would come under attack during rebellions and civil wars.

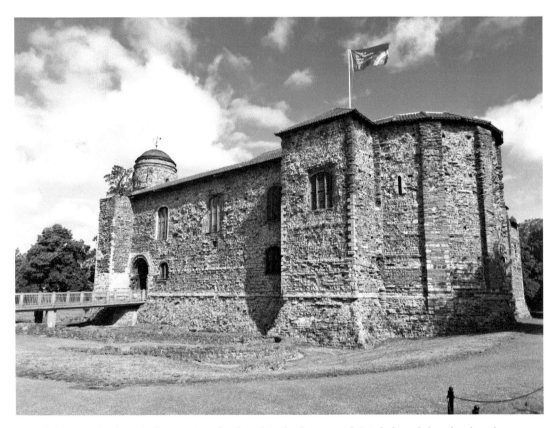

Colchester Castle with the remains of a chapel in the foreground. It is believed that the chapel was originally built by the Saxons and later rebuilt by the Normans.

2. Revolt and Civil War

One of the last stone-built Norman castles constructed in Essex was Walden Castle in Saffron Walden. It was built in 1141 by Geoffrey de Mandeville, son of William de Mandeville of Pleshey, during a period often referred to as 'the Anarchy'. Geoffrey was a supporter of King Stephen when he claimed the crown following the death of Henry I in 1135, and was made Earl of Essex and constable of the Tower of London. During this period Matilda, the daughter of Henry I, challenged Stephen as the rightful heir. Geoffrey believed the tide was turning when Stephen was captured in 1041 and switched allegiances to Matilda. When Stephen looked to regain control from Matilda, Geoffrey switched sides back to Stephen. By this point Geoffrey was no longer in the king's favour. In 1143, Geoffrey was imprisoned in the tower he was once constable of, being released once his castles had been taken from him. Geoffrey fled to Ramsey Abbey, in what is now Cambridgeshire, expelling the monks and fortifying his position. In 1144, Geoffrey died during an attack on Burwell Castle, near Newmarket. He never regained any of his castles, and in 1157 Waldon Castle was completely destroyed upon the request of Henry II, King Stephen's successor.

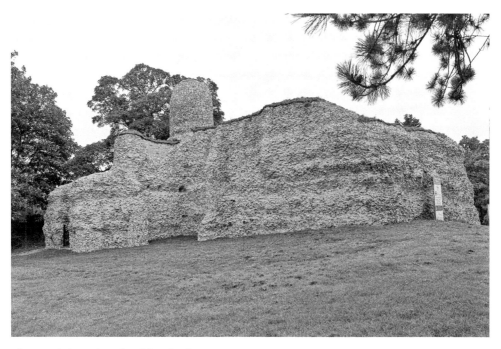

The remaining ruins of Waldon Castle.

Following the death of King Stephen in 1154, Henry II began the reign of the Plantagenet dynasty. Over the next fifty years three of his sons would become king of England. It was during the reign of King John that relations between the king and nobility became particularly strained. King John's ineptitude, both militarily and diplomatically, resulted in his barons forcing John to sign the Magna Carta – a charter to limit the king's power. Although the king was forced to agree to the charter, within months he declared war on the rebel barons. Out of the twenty-five rebel barons who forced the king to honour the charter, five were based in Essex: Geffrey de Mandeville, 2nd Earl of Essex, based at Pleshey Castle; Richard de Montfitchet of Stansted Castle; William Lanvallei of Colchester Castle; Robert Fitzwalter, Lord of Dunmow; and Robert de Vere of Hedingham Castle. Essex suffered during this period at hands of marauding Royalist armies, the events recorded in graphic detail by the Cistercian abbot Ralph of Coggeshall.

In late 1215, King John journeyed north to defeat the northern rebels, while an army of French mercenaries led by one of John's captains, Savari de Mauleon, travelled south to Stansted Castle. It is believed that Richard de Montfitchet was not present, and his garrison either surrendered or fled Mauleon's force, which was significantly larger. The castle was looted, the village ransacked, and many building torched. The royalist army continued east to Pleshey Castle, the seat of Geoffrey de Mandeville. On 24 December 1215, Pleshey Castle was attacked, and once again the local village plundered. Similar to Stansted, Pleshey's garrison was vastly outnumbered by the royalist army and offered little resistance. Between 25 December 1215 and 1 January 1216, the royalist army attacked the Cistercian abbey at Tilty and Coggeshall, stealing anything of value; several monks were also killed during this period. The royalist forces then made their way north to Suffolk, inflicting the same level of savage destruction as in Essex, before returning to Essex to attack Colchester Castle. William de Lanvallei had strengthened Colchester Castle after it had been restored to him under the terms of Magna Carta and reinforced his own garrison with a detachment of French soldiers loyal to Louis (Dauphin of France), who was invited to assume the throne of England by a number of the rebel barons.

When Mauleon's forces arrived at Colchester in late January 1216, he realised that taking the castle would be far more difficult than at Stansted or Pleshey. Colchester was an impressive stone castle, with a large and well-supplied garrison. Mauleon knew that taking the castle with the force he had would be nearly impossible, and so instead attacked and looted the town of Colchester and travelled north to join forces with King John in Suffolk a few days later. Following a surprisingly easy victory at Framingham Castle, the combined forces of King John and Mouleon arrived back at Colchester Castle on 14 March 1216. After five days laying siege to the castle, the king offered free passage to the occupying English and French forces if they surrendered. The garrison agreed to the terms a few days later, and the French soldiers were allowed to travel to London while the English rebel force were imprisoned.

With Colchester now in royal hands, the next rebel baron stronghold to face the king's wrath was that of Robert de Vere's Hedingham Castle. Hedingham was equally as imposing as Colchetser Castle; however, its design meant it was not well equipped to successfully defend against a siege. It had no moat, and although built on the high ground of the area, it was vulnerable to being undermined. On 25 March 1216, the king and his

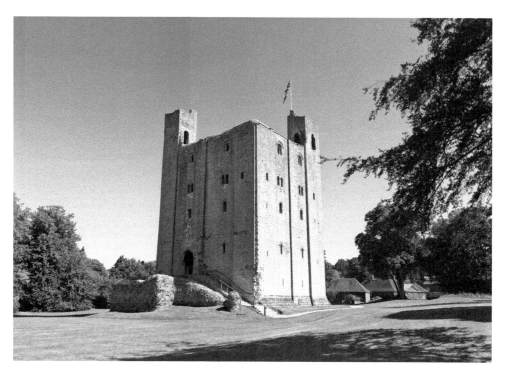

Hedingham Castle with two of the original four turrets that survive today.

army arrived at Hedingham Castle. Within a few days Robert de Vere had surrendered his castle and estates, swearing his allegiance to King John to save his castle from destruction. With this defeat, all the Essex rebel barons had lost control of their castles and estates; however, it was the people of Essex who had suffered the full force of King John's terror. In October 1216, King John died and his son Henry III revised a version of the charter that restored the Essex barons' lands to them. It would take much longer for the villagers and ordinary people of Essex to recover from this civil war.

The fourteenth century proved equally troublesome for English kings. It was a turbulent time: the Black Death reduced the population by approximately 40 per cent, which forced the English Parliament to create the Statutes of Labourers in 1351, limiting the independence of peasants' work. In addition, the poll taxes levied in 1377, 1379 and 1381 forced the peasants to pay for the war against France. These events ultimately led to the Peasants' Revolt in 1381, and in Essex to the Battle of Billericay, also known as the Battle of Norsey Wood, on 28 June. The king reneged on his promise to accept the rebel's demands, which led to hundreds of Essex men taking up arms against the king. These Essex men were not professional soldiers and when the king's men charged at dawn on 28 June 1381 the peasants' flimsy defences and poorly formed ranks posed no match for the king's cavalry and soldiers. Some 500 Essex men were killed; many are believed to be buried at the churchyard at Great Burstead.

Once again, this time in 1642, Essex would play its part in the nation's internal conflict. During the First Civil War between Parliamentarians and Royalists, Essex was a strong

Parliamentary supporter. By the end of 1642 it had provided some 2,000 men for service in their armies. However, not everyone from Essex was on Parliament's side. Career soldier and Royalist supporter Sir Charles Lucas, whose family was from Colchester, would have a prominent role to play in the Second Civil War and the Siege of Colchester in 1648.

In 1648, rebel forces loyal to King Charles led by George Goring, Earl of Norwich, marched on Colchester following a defeat by Sir Thomas Fairfax's Parliamentary forces in Kent. Goring was joined by Lord Arthur Capell and troops from Hertfordshire, and Sir Charles Lucas with men from the Essex Trained Bands who had defected to the Royalists. Colchester was intended to be a base from which additional troops could be recruited to join the 4,000–6,000 already mustered. The town's defences were in relatively good condition, having been refurbished at the beginning of the First Civil War when the town petitioned Parliament for financial assistance to do so. Fairfax, realising the threat this posed, transported his troops across the Thames at Tilbury and arrived outside Colchester's town walls on 13 June, calling for the Royalists to surrender. Fairfax was joined by the Essex Trained Band, loyal to Parliament, under Sir Thomas Honeywood, and Colonel John Barkstead's Infantry Brigade from London.

This gap in the Roman wall near St Mary's Church was used to fire Royalist cannons of the King's Battery to defend Colchester during the Civil War siege of 1848.

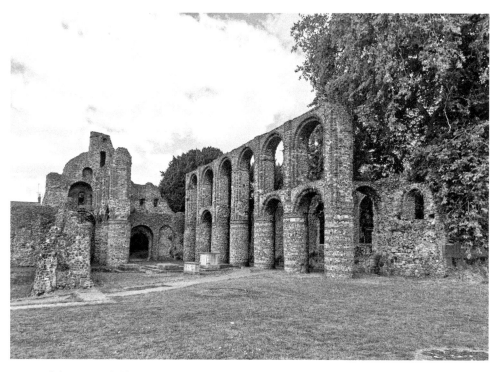

Ruins of the St Botolph's Priory, which were badly damaged by cannon fire during the Civil War siege of 1648 and never repaired.

Although the Parliamentary and Royalist forces were of equal size, the Parliamentarians were far more experienced and better equipped. The Royalists filled the gaps in the town wall in the northern part of the circuit with earth ramparts, and established a fortified positioned outside the town walls along the approach roads to the town. Fairfax's direct attacks on the town failed and resulted in losses of 500 to 1,000 men. This gave way to the siege specialist Colonel Rainsborough beginning the eleven-week siege. Some forty heavy cannons were brought from London and strategically sited around the town, and a dozen forts were built. On 5 July, the Royalists successfully attacked the Parliamentary forces guarding the East Gate; however, they tried to capitalise on their swift victory and travelled too far into town where they suffered heavy losses from Parliamentary counter-attack.

On 14 July, the Parliamentary force attacked and captured St John's Abbey and with it the family home of Sir Charles Lucas. There seemed little hope of a Royalist relief force, and when the crushing news of Cromwell's victory at the Battle of Preston reached Colchester, the Royalist army unconditionally surrender on 28 August. The lower ranks were given quarter and allowed to return to their homes once they swore an oath not to take up arms against Parliament again. The fate of the Royalist leaders – Goring and Capell – was left with Parliament, while the Royalist commanders at Colchester – Sir Charles Lucas and Sir George Lisle – were found guilty of high treason during a court martial and executed by firing squad.

The siege house at East Street, Colchester. Evidence of musket fire during the siege can still be seen in the building timbers.

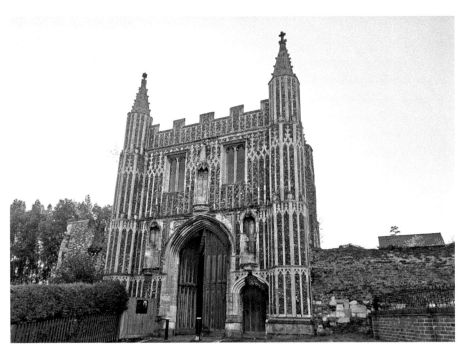

Gatehouse of the Benedictine abbey of St John, part of the Lucas family's mansion that was bombarded and stormed by Parliamentary soldiers.

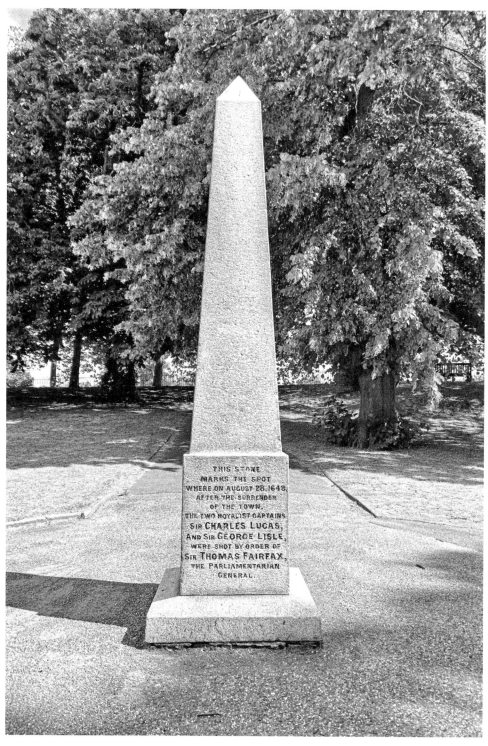

Memorial to Charles Lucas and George Lisle, marking the spot of their execution near Colchester Castle.

3. Familiar Foes

From the Romans to the Plantagenets, for centuries the English and Essex coastlines had been the target for many invaders; for a further 500 years, Essex would be prepared to repel repeated threats of attack from the French, Dutch and Spanish. One of the earliest defence sites against the French in Essex, post-Norman Conquest, is Hadleigh Castle. Overlooking the Thames Estuary, it was built by AD 1230 and licensed by Hubert de Burgh, who was granted the manor of Rayleigh by King John to replace the outdated motte-and-bailey Rayleigh Castle. King John had already dealt with the rebellion of the barons, and now the threat from the French needed addressing. The hit-and-run tactics of the Franco-Spanish fleet in 1380 along both sides of the estuary were hard to defend against; however, the castle at Hadleigh would serve as a warning to would be attackers. Ultimately its garrison would be too far from the water to mount any meaningful counter-attack, though warning beacons could be lit, allowing people to retreat inland for safety.

In the early part of the Hundred Years' War, Henry VIII's response to the threat of invasion was to build additional or permanent defences in places that had historically had temporary, and often inadequate, defences. This included building two permanent blockhouses at Tilbury in 1539 – at present-day Coalhouse Fort and Tilbury Fort – as well as three blockhouses in Harwich in 1543 when the king designated Harwich a Royal Navy dockyard as part of his programme to expand the navy. Additional blockhouses were built further south along the Essex coast, at Brightlingsea, St Osyth, and the far east side of Mersea Island. All of these blockhouses were abandoned and left derelict within ten years of being built, having never been tested against the French.

In 1588, a new threat loomed when the 130-ship Armada from Spain set out to invade England. A defensive boom was constructed using ships' masts and chains from Tilbury to the other side of the Thames at Gravesend, to prevent enemy ships from reaching London. An army of over 20,000 soldiers formed from the county militias camped at West Tilbury, and was visited by Queen Elizabeth in August 1588 to give her famous speech to rally her troops. However, the attack on the anchored Spanish fleet by the English flotilla in July caused a level of destruction that meant an attack on England had to be abandoned. Once again, the defences in Essex were not tested in battle.

The series of Anglo-Dutch wars fought between 1652 and 1674 demonstrated how inadequate Essex's defences had become. These wars were predominantly fought at sea, with the Gunfleet anchorage, off the coast of Holland-on-Sea, being used by the English fleet to launch their attacks. In 1664, the Harwich Royal Dockyard was reopened due to its strategic importance, having been closed by Charles II to save money, and built the sixty-six-gun third-rate ship of the line, HMS *Rupert*. In June 1667, a Dutch fleet entered the Thames Estuary and raided along the River Medway. It destroyed the HMS *Royal*

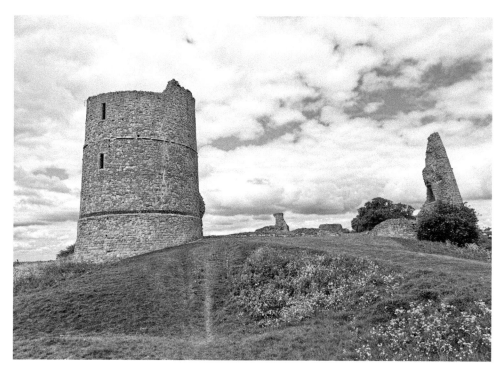

The ruined fourteenth-century south-east tower, to the left, stands almost to its original height.

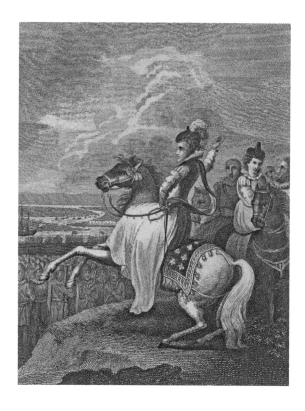

Queen Elizabeth I rallying her troops at Tilbury.

James, Loyal London and *Royal Oak*, and also seized and towed HMS *Royal Charles* to the Netherlands. The Dutch fleet sailed down the River Thames but turned away before reaching Tilbury, believing that the blockhouses there were in good order. Instead, they turned back and raided Canvey Island for supplies. Despite its commanding position overlooking the estuary, Hadleigh Castle had been left to ruin and posed no significant military threat, nor was it manned to provide a warning of potential invasions. In early July, the Dutch fleet attacked Harwich; however, the attack stalled when the Dutch flagship ran aground.

The attacks by the Dutch in 1667 demonstrated that England was not adequately prepared and had the blockhouses at Tilbury been challenged, London would have certainly suffered dearly. Sir Bernard de Gomme, chief Royalist engineer during the Civil Wars, completed a survey of Britain's coastal defences upon the restoration of the monarchy in 1660. Charles II commissioned de Gomme to implement his recommendations, which included the need for the Thames to improve its defences. The blockhouse at West Tilbury was decided as the best location for the new Tilbury Fort. In 1670, building works began on a pentagonal fort with five bastions enclosing the original West Tilbury blockhouse. Surrounding the fort were moats, ramparts and ditches, with the fort's armaments along the riverfront. The old blockhouse was now used as a magazine store, and a permanent barracks was built within the defences for the fort's garrison. Tilbury Fort would undergo various improvements during the eighteenth century, though in many instances this would simply be by improving the armaments.

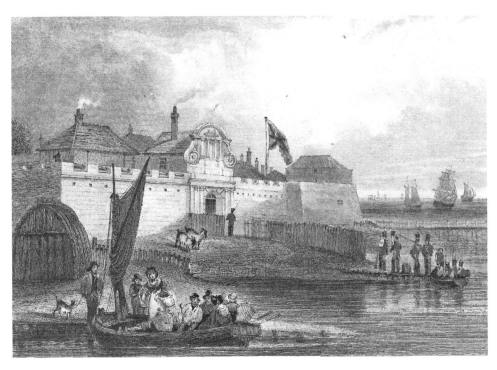

A view of Tilbury Fort in 1831.

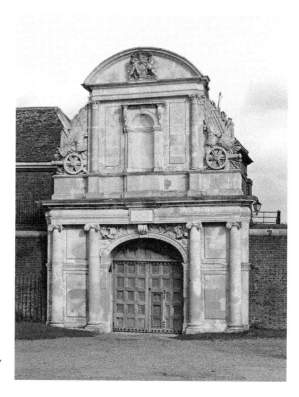

The main entrance to Tilbury Fort, now under the care of Historic England.

The manufacture, distribution and storage of gunpowder is another significant part of Essex's military heritage that came to prominence during the eighteenth century as a result of issues arising from conflicts with the Dutch, French and, later, the colonies in America. During the wars with the Dutch in the seventeenth century, the quality and supply of gunpowder had been inconsistent, with similar problems presenting themselves during the Seven Years' War and American Revolution in the mid- and late eighteenth century. During the Seven Years' War the facilities at Greenwich were deemed inadequate, and in 1763 the construction of a new depot was established at Purfleet, consisting of five magazines, a proof house, storekeeper's house, cooperage and barracks. Each magazine could hold up to 10,000 barrels of gunpowder, ensuring that an eighteen-month supply was readily available, preventing the shortages that plagued the military in previous conflicts with the Dutch. Purfleet would become the main storage and distribution facility of gunpowder for the Royal Arsenal at Woolwich, plus the naval ordnance yards along the Thames and Medway. Purfleet received its supply from the gunpowder mills at Waltham Abbey from 1787, after a shortage of gunpowder during the Second Anglo-Dutch War prompted the government to purchase the mill. The newly named Royal Gunpowder Mills at Waltham Abbey continued to produce high-quality gunpowder, as well as the explosives, Cordite, TNT and RDX, for over 300 years.

In an attempt to improve Britain's coastal defences during the Napoleonic Wars, 103 Martello towers were built between 1804 and 1812, of which eleven of these were built to guard a 13-mile stretch of Essex coastline, from Point Clear near St Osyth, to Walton on

Purfleet Magazine No. 5, built in 1759. The other four gunpowder magazines were demolished in the 1960s. No. 5 is now home to the Purfleet Heritage & Military Centre.

The former gunpowder Proof House at Purfleet.

the Naze. The towers were based on a sixteenth-century Genoese circular fort at Mortella Point in Corisca that withstood a furious attack by the Royal Navy in 1794. Each tower was garrisoned by an officer and up to twenty-four men, with separate accommodation available on the first floor. The towers had stores for food, powder and other supplies, with either a well or cistern providing the occupants with water, allowing them to resist against enemy attacks for lengthy periods. By the time the chain of Martello towers had been completed, and following the Royal Navy's victory at the Battle of Trafalgar, the threat of invasion has passed. The towers in Essex were lettered A–K, with Tower A at Clear Point guarding the mouth of the of the Colne Estuary, which still survives today along with towers at Jaywick (C), West Clacton (D), Clacton Beach (E), Clacton's Marine Parade (F) and Walton Mere (K).

The string of Martello towers along the Essex coast was supported by another larger, circular fort at Harwich, the redoubts. Built in 1808 to 1810, the Harwich Redoubt was based upon the same designs of the redoubts along the southern coast, being some 200 feet in diameter and with its upper floor mounting ten 24-pounder guns. The Harwich Redoubt's elevated position gave it clear views in all directions to protect the port at Harwich. Accessed by a drawbridge, it was surrounded by a 20-foot-deep dry moat and could garrison 300 men.

Martello Tower A at St Osyth, currently a museum run by the East Essex Aviation Museum Society.

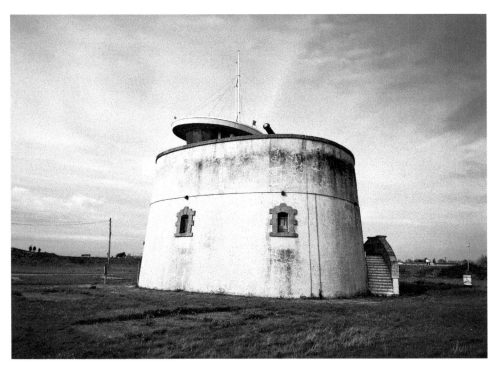

Martello Tower C at Jaywick, now a local arts, heritage and community venue.

Martello Tower F, the only remaining dry moated example on the Essex coast, with later observation platform.

The chain of Martello towers and the Harwich Redoubt were also supported by a newly formed maritime militia, the Sea Fencibles. This was a part-time organisation, whose volunteers were local fisherman and boatmen under the command of a naval officer and could be mobilised to defend the coastline between Leigh and Harwich from invasion. This coastal militia was established in 1798, during the French Revolutionary War, until 1801. It was then reactivated again during the Napoleonic Wars, from 1803. The Sea Fencibles were stood down in 1810 when the threat of the French invasion had passed. Their duty was to carry out patrols close to the shore to signal an enemy approaching, with some vessels carrying weapons to challenge enemy ships. They were only required to train a few hours a week, which allowed them to continue with their normal work until being called upon; it was being exempt from being impressed into the navy that made it appealing to those working in coastal communities.

It was hoped that the defences along the east coast would prevent an invasion; however, given that it was only three days' travel by foot from the Essex coast to London, a number of military camps were established across Essex. Temporary camps were set up across Essex, including at Writtle, Widford, Brentwood, and Maldon. In 1803, a camp was built south of Chelmsford, between Widford and Galleywood Common, for 15,000 men and 200 guns. In Colchester, a permanent camp housed over 7,000 soldiers by 1803, doubling the town's pre-war population. A barracks was established at Weeley to provide additional accommodation for troops, including coastal defence forces to supporting those garrisoned at nearby Martello towers.

The interior of the redoubt at Harwich, built in 1808 to defend Essex from Napoleonic invasion.

4. The Victorian and Edwardian Military

During Queen Victoria's reign, Britain found itself involved with a number of overseas conflicts. However, it was fear of the French navy and their newly built iron-clad ships that once again resulted in the construction of new permeant coastal and river defences in Essex. These new defences were called Palmerston Forts, named after the staunch supporter of this scheme and the prime minister of the day, Lord Palmerston. However, the forts also went by the name Palmerston Follies, due to numerous debates as to the military effectiveness of these costly fixed fortifications. Essex had of two of these forts constructed: Coalhouse Fort at East Tilbury and Beacon Hill at Harwich, while defences at Tilbury Fort were upgraded.

Along the River Thames, Tilbury Fort had long been considered the capital's primary line of defence; however, a royal commission set up in 1859 to survey the nation's defences led to a recommendation to make the primary line of defence further upstream. In 1861, construction on a new fort began at Coalhouse Point, which was completed in 1874. The unnecessarily long time taken to complete the fort was due to continual advancements in artillery technology. Meanwhile, Tilbury Fort had many of its guns replaced, as many could not pierce the armour of iron-clad ships and its profile lowered.

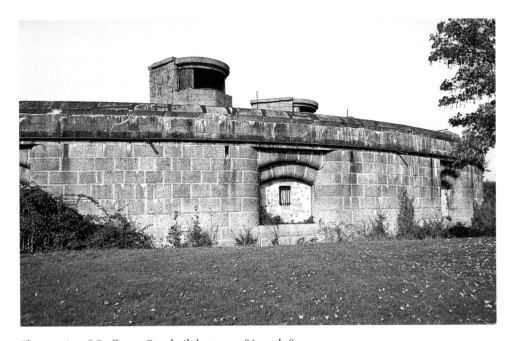

The exterior of Coalhouse Fort, built between 1861 and 1874.

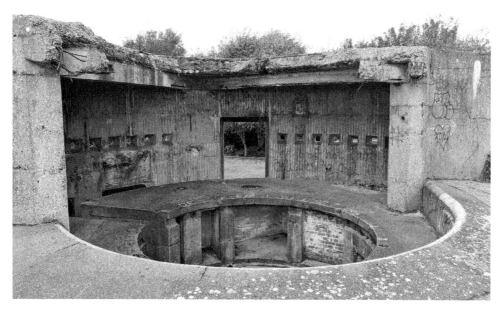

The Beacon Hill Battery gun emplacement, built by 1890.

By 1886, these new and expensive defences were considered obsolete, leading to another revision of Essex's defences. It was determined that new batteries would need to follow the Twydall Profile, a design perfected at Chatham that used low-profile crest and earthworks with unclimbable fences. This new type of battery was built a short distance from Coalhouse Fort at East Tilbury in 1892 and was armed with guns fixed to hydro-pneumatic disappearing carriages, which remained hidden and only appeared briefly when fired. The redoubt at Harwich had several of its obsolete guns replaced in 1870 with 9-inch rifled muzzle loaded (RML) guns. When in 1887 Harwich was deemed a possible target for invasion, Beacon Hill was selected as a site for a new battery, and was built to the same design as East Tilbury. By the end of the nineteenth century many of the RML guns had been replaced by a combination of quick-firing (QF)and breech-loading (BL) guns.

Throughout the Victorian era the development of more powerful artillery meant that the continued use of the gunnery ranges at Plumstead Marshes, near the Woolwich Arsenal, proved too dangerous with the increase in commercial and civilian traffic along the Thames. In 1849, a site at Shoeburyness was purchased by the government. At first it was only used during the summer; however, the Crimean War in 1854 prompted an increased effort in artillery development, testing and proving. As a result the Shoebury Garrison became the permanent establishment and home to the School of Gunnery in 1859. From 1899, a 'New Range' was established north of East Beach, on Foulness Island. In the final quarter of the nineteenth century, the Shoebury Garrison would play a pivotal

The clock tower and entrance to Horseshoe Barracks parade ground at Shoeburyness.

The Powder Magazine and remnants of a narrow-gauge railway at Shoeburyness, built in 1856.

role in the development of experimental artillery, explosives and defensive casemates, which included developing rifled barrels, BL and QF guns, shrapnel, and the replacement of gunpowder with cordite.

New ordnance, munitions and small arms factories were established at various locations throughout Essex during the mid- and late nineteenth century, with the demand for military explosives increasing during the First Boer War in 1880, and again during the Second Boer War of 1899. In 1867, Alfred Nobel had gained patents on an invention called dynamite – a safer way of handling the dangerous explosive nitroglycerine. His innovation led to him establishing a factory in Scotland and then, as a partner in the British Explosives Syndicate, he opened a new factory in Pitsea in 1891. At the turn of the twentieth century, explosives production focused on producing cordite, a smokeless explosive that was used in single-part cased military ammunition, usually for breech-loading quick-firing guns. In 1897, a second explosives and small arms and factory opened at Shell Haven, which became known as Kynochtown. Pitsea and Kynochtown both closed soon after the First World War due to lack of demand.

The Royal Small Arms Factory (RSAF) at Enfield, established in 1816 and built on a marshy island in the Waltham Abbey parish of Essex, had pioneered the use of machinery for the production of interchangeable parts for small arms, sustaining the surge in demand for small arms during the Crimean War in 1853. However, the design and production of the iconic Lee Enfield rifle at the RSAF is arguably its most significant contribution. The British Army adopted the Lee Enfield as its standard service rifle from

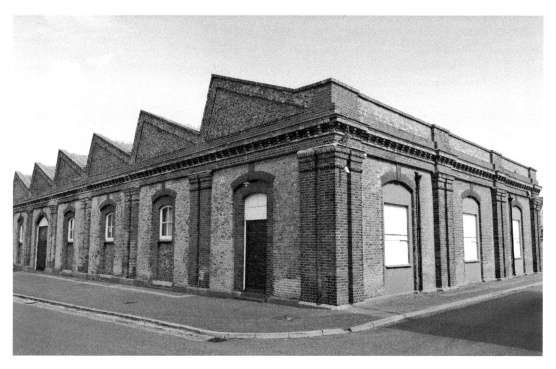

Gunnery Drill Sheds at Shoeburyness, built 1859–60.

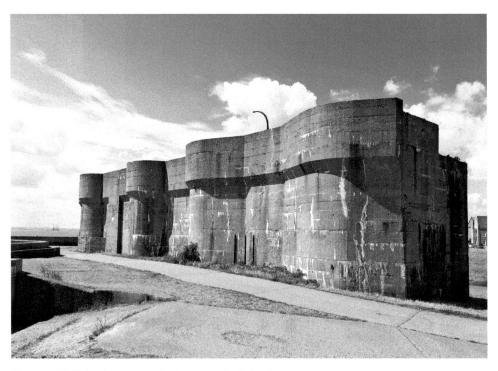

Heavy quick-firing battery at Shoeburyness, built in 1899.

1895 and it saw service through both world wars and beyond. The site would also produce other iconic weapons, such as the Bren and Sten – the 'en' in the name of each weapon identifying Enfield as the place of design.

The Crimean War prompted the War Office to recognise the need for an organised, well-equipped and trained standing army. The system of billeting soldiers with private homes and inns was no longer seen to be best solution. Colchester had numerous barracks built during the Napoleonic Wars, but they were demolished soon after the British victory at Waterloo. In 1855, it was decided to build a new hutted camp at Colchester, consisting of six blocks of huts. Each provided accommodation for an infantry battalion, as well as a timber-framed chapel and a ten-ward hospital.

The Garrison Chapel is earliest surviving building of the Colchester Garrison, while many buildings of the Cavalry Barracks, constructed between 1862 and 1863, also survive today. Colchester's military footprint continued to grow, and between 1874 and 1875 the Artillery Barracks was built. It was renamed Le Cateau Barracks after the First World War in recognition of the Royal Field Artillery's actions during the retreat from the Battle of Mons in 1914.

Between 1894 and 1904, wooden huts were replaced with brick buildings to create Meeanee and Hyderbad Barracks, to the east of the old Abbey Field drill ground. The layout of these new brick-built barracks followed the original plan of the 1856 timber-built camp. In 1900, Goojerat Barracks was built to the west and Sobraon Barracks to the south of Abbey Field, the latter was last occupied in 1960 and was demolished in 1971.

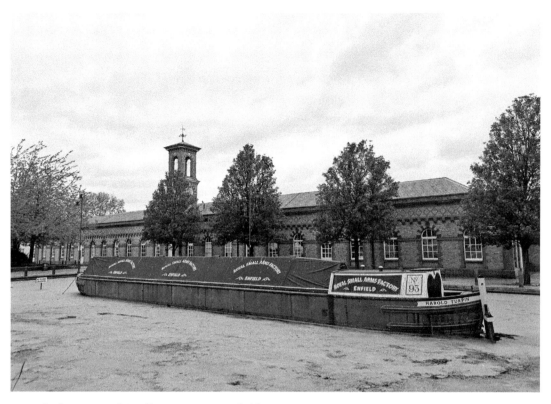

The former Royal Small Arms Factory, Enfield.

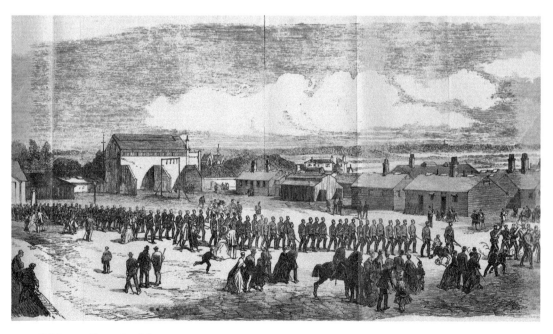

Colchester Camp in 1869.

The former Garrison Church in Colchester. Built in 1856, it is the only surviving part of the temporary hut camp established for the Crimean War.

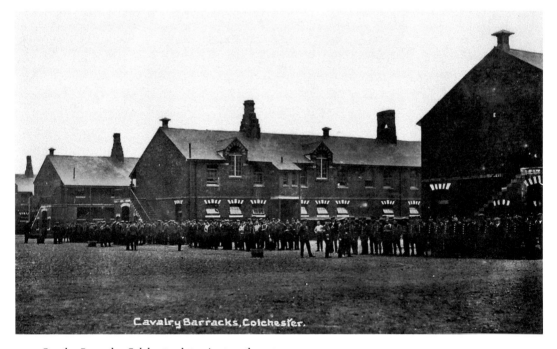

Cavalry Barracks, Colchester, late nineteenth century.

Sobraon Barracks, Colchester, early twentieth century.

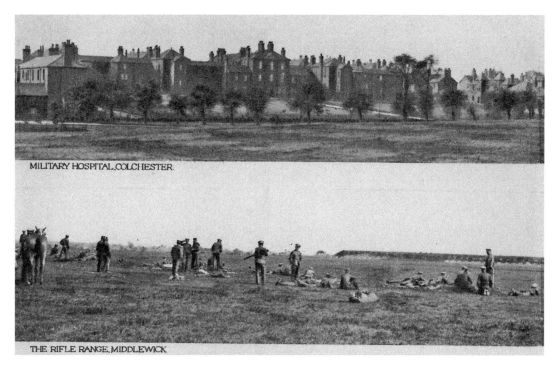

The Military Hospital, Colchester, demolished in the 1990s, and the rifle ranges at Middlewick.

As Colchester grew as a garrison town during the Victorian era, so did the need for additional training and welfare facilities. In 1857, the government purchased 167 acres at Middlewick Farm to the south of the new brick-built barracks, creating a rifle range and drill ground. The garrison gymnasium was built in 1862, when the British Army adopted a formal military gymnastics programme and established the Army Gymnastic Staff in 1860. Between the site of Sobraon Barracks and the Garrison Gymnasium is the site of the former Military Hospital, which was demolished in 1995. Built in 1896, the brick-built hospital replaced the 1873 centralised hutted camp hospital, which had replaced the earlier regimental hospitals.

The final significant Victorian military development for Essex was the reforms associated with the regular army, militias and volunteer forces. The Crimean War of 1853–56 and later the First Indian War of Independence (1857–59), highlighted the need for organisational and administrative reforms. The 1871 Regulations of Forces Act, part of the Cardwell Reforms, and 1881 Childers Reforms, ensured the two regular army units – the 44th and 56th Regiment of Foot – would forever be tied to the county of Essex (this will be explored further in the next chapter).

First raised in 1798 due to the threat of French invasion and disbanded in 1828, the Essex Yeomanry Cavalry was, after a very short break, reformed as the West Essex Yeomanry in 1830. The West Essex Yeomanry Cavalry, raised by Colonel George Palmer of Nazing Park, was initially tasked with protecting the gunpowder mills at Waltham Abbey and the Royal Small Arms Factory at Enfield. Colonel Palmer financed the troop between

The former Garrison Gymnasium in Colchester.

1838 and 1843, until the troop was returned to the army establishment. In 1871, the West Essex Yeomanry Cavalry reverted back to its former name as the Essex Yeomanry Cavalry until 1877 when the regiment disbanded. In 1889, Captain (later Colonel) R. B. Colvin raised an Essex troop of the Loyal Sussex Hussars, who served in South Africa during the Second Boer War as part of the Imperial Yeomanry. Colvin commanded the 20th Battalion Imperial Yeomanry, known as the 'Roughriders', to fight the highly mobile Boer Commandos. In 1901, the authority was given to the Lord Lieutenant of Essex, the Earl of Warwick, to raise the Essex Imperial Yeomanry. In 1902, Colvin was tasked with raising this new yeomanry, and established squadrons based on the locations of the four hunts in the county. When the Territorial Force was created in 1908, the regiment was renamed the Essex Yeomanry and became part of the newly formed Territorial Force, along with other volunteer units in Essex.

At the beginning of Victoria's reign the Essex militia were organised into two units: the East Essex Regiment of Militia (later the Essex Rifles Militia) with their headquarters in Colchester, and the West Essex Regiment of Militia, whose headquarters were at Chelmsford. The Childers Reforms of 1881 resulted in the two Essex militia units becoming the 3rd and 4th (Militia) Battalions of the Essex regiment, and following the creation of the Territorial Force in 1908, the two militia battalions were reduced and renamed the 3rd (Special Reserve) Battalion.

Inspection of West Essex Yeomanry Cavalry on Wanstead Flats in 1853.

Inspection of the Essex Rifles (Militia), Colchester, 1869.

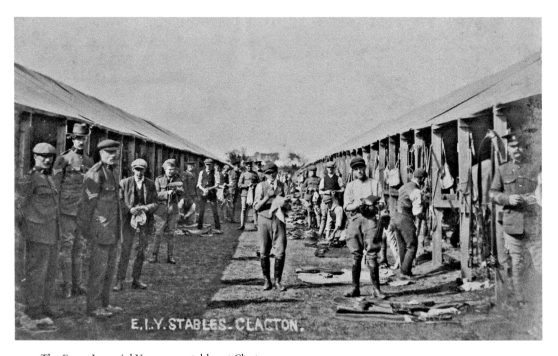

The Essex Imperial Yeomanry stables at Clacton.

From 1859 onwards a number of Rifle Volunteers Corps were established in Essex, with some twenty-five corps raised and three administrative battalions in Ilford, Colchester and Plaistow. With the perceived threat of invasion from France and a vast number of regular troops committed to foreign campaigns, the Volunteers would support the remaining regular troops and militia units from foreign invasion. Over time various corps disbanded due to the financial burden; however, many corps were sponsored by local industry, which also acted as a recruiting pool. In 1881, the county's Volunteer Rifle Corps were amalgamated into four battalions and designated the 1st through 4th Volunteer Battalions of the Essex, and from 1908 were renumbered the 4th through 7th Battalions of the Essex Regiment.

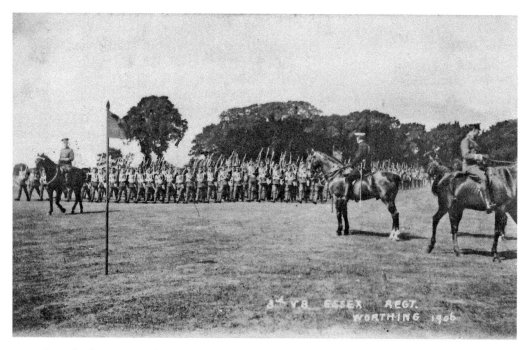

The 3rd Volunteer Battalion Essex Regiment parading at Worthing in 1906.

5. The Fighting Fours and Pompadours

Over the years there have been many military units and regiments that have made Essex their home; however, none are more famous than the 44th and 56th Regiment of Foot, 'The Fighting Fours' and 'Pompadours', who in 1881 would become the 1st and 2nd Battalions of the Essex Regiment. The connection to Essex for these regiments began a hundred years earlier, when in 1781 a system of linking regiments with counties took place and the two regiments were renamed the 44th (East Essex) and 56th (West Essex) Regiment of Foot.

The 44th Regiment of Foot was formed in 1741 during the Austrian Succession, while the 56th Regiment of Foot was formed in 1755 as a result of the impeding conflict that would later be known as the Seven Years' War. The 44th Foot were known as 'The Fighting Four' due to the courage of the regiment during the Battle of Salamanca in 1812. The 56th Foot earned the nickname the 'Pompadours' for the colour of their uniform's collar, lapels and cuffs, which were reportedly the same shade of purple as the favourite colour of the Marquise de Pompadour, mistress to King Louis XIV. During the eighteenth century both regiments would see action overseas, although the 44th were first tested in battle at Prestonpans during the Jacobite Rebellion in 1745 before fighting overseas in Flanders in 1747 during the War of Austrian Succession. Between 1755 and 1786 the 44th spent a considerable amount of time in North America, fighting in the French and Indian Wars, a campaign of the larger Seven Years' War, and later during the American Revolutionary Wars. The 44th remained in North America until 1765 when they returned home, only to go back ten years later at the start of the American War of Independence. There they fought at the battles of Brooklyn in 1776, Brandywine in 1777 and Germantown in 1778, before travelling to Canada in 1780 and returning to England in 1786.

The 56th Regiment of Foot first saw overseas service in 1762 in Cuba as part of the Seven Years' War, where they took part on the siege and capture of Havana. It was subsequently awarded the battle honours 'Moro', and many years later 'Havannah'. In 1765, the regiment spent five years on garrison duty in Ireland until it again saw overseas service in Gibraltar, where the 56th was garrisoned during the Siege of Gibraltar from 1779 to 1783. Despite being overwhelmingly outnumbered by French and Spanish forces, the British garrison at Gibraltar successfully repelled their attackers, and the 56th earned the battle honour 'Gibraltar, 1779–83', and the right to bear its regimental colour with 'Castle and Key' and motto 'Montis Insignia Calpe'.

The 44th served overseas in the West Indies during the French Revolutionary Wars, and arrived in Egypt during the first Napoleonic War in 1800. The British Army continued to expand in the early nineteenth century, with the 44th (East Essex) Regiment raising a second battalion and 56th (West Essex) Regiment a second and third battalion, until they were all disbanded by 1816. The 1st Battalion 44th Foot travelled to North America in 1814

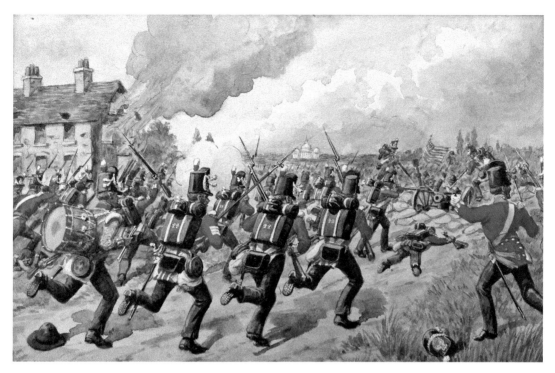

The 44th Foot at the Battle of Bladensburg, 24 August 1814. (Painting by Richard Simkin; Major P. H. Williamson)

and fought in the war of 1812 with a victory at Bladensburg en route to burning down the White House. The 2nd Battalion 44th Foot travelled to Portugal in 1810 and fought in many battles during the Peninsula War, including the Battle of Salamanca in July 1812. It was during this battle where Lieutenant William Pearce captured the Imperial Eagle standard of the 62nd Regiment of French Infantry – one of only five taken by British forces during the Peninsula War.

During the early stages of Queen Victoria's reign, both regiments served at home and overseas during the various 'small wars' and expeditions, which included: India; Burma, for which the battle honour 'Ava' was awarded; and Afghanistan. It was during the First Afghanistan War in 1842 that the 44th and the British Army, showing great courage, suffered their worst defeat and revealed their vulnerability to the world. The 44th were sent to Kabul in 1841, but an uprising forced the British garrison there to retreat to Jellalabad in January 1842. Through narrow, snowy mountain passes the British column was annihilated. As the rearguard, twenty men of the 44th made a last stand at Gundamuck. During the final stages of the retreat Lieutenant Thomas Souter tore the Regimental Colour from its pike and, in an attempt to hide it from the enemy, wrapped it around his body. When the final massacre occurred the Afghans noticed the rich material of the Colour around Souter's body and assumed he was a person of high status, either by birth or rank. His life was spared, and he and the regimental colours would later be returned.

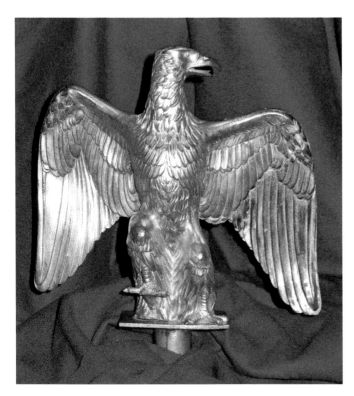

The Salamanca Eagle can be seen on display at the Essex Regiment Museum in Chelmsford. (Essex Regiment Museum)

The Last Stand of the 44th Foot at Gundermuck, 1842. (Painting by William Barns Wollen in 1898; Essex Regiment Museum)

In 1853, the Crimean War required the services of both regiments, where they received the battle honours 'Alma', 'Inkerman' and 'Sevastopol', and Sergeant William McWhiney of the 44th was awarded the regiment's first Victoria Cross. In 1857, both regiments were despatched to India during the First War of Indian Independence but arrived after the native troops had be subdued. However, it would not be long before the 44th would see action again. During the 1860 war with China the 44th took part in capturing Taku Forts, where Lieutenant Robert Montresser Rogers and Private John McDougall swam the ditches surrounding the fort, entering the fort by pushing bayonets into the walls to help them climb. They were the first British soldiers to enter the fort, subsequently being awarded the Victoria Cross for their gallant actions.

In 1881, the Cardwell Reforms brought the 44th (East Essex) and 56th (West Essex) Regiments together to form the 1st and 2nd Battalions of the Essex Regiment. They were assigned to Military District No. 44 at Warley Barracks, near Brentwood, which originally opened in 1805. Developed from a hutted camp some years earlier, it was expanded to accommodate two troops of horse artillery and 300 to 400 infantry soldiers. In 1842, the East India Company established its depot at Warley Barracks, having outgrown its home at Chatham, and a chapel was built in 1857.

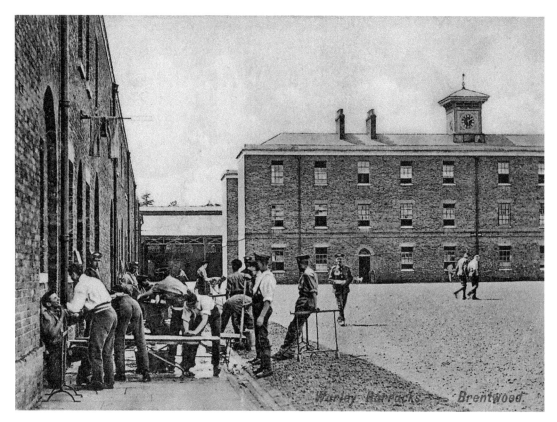

View of Warley Barracks, featuring the former clock tower. The clockface is now displayed at the Army Reserve Centre at Warley.

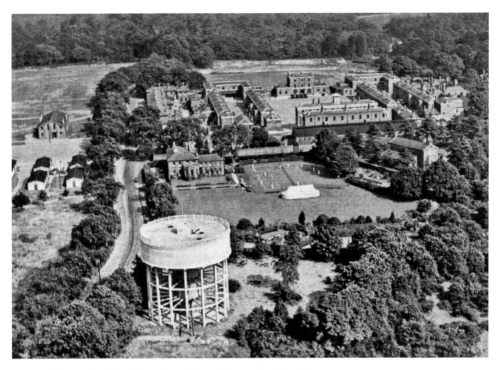

An aerial view of Warley Barracks prior to being redeveloped.

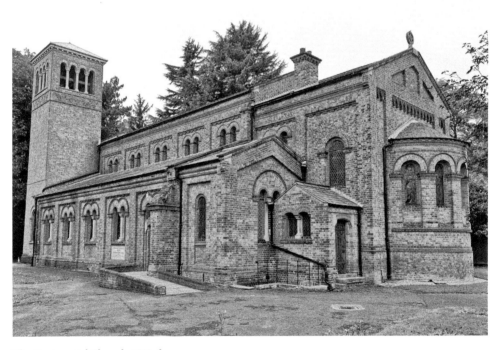

The Regimental Chapel at Warley.

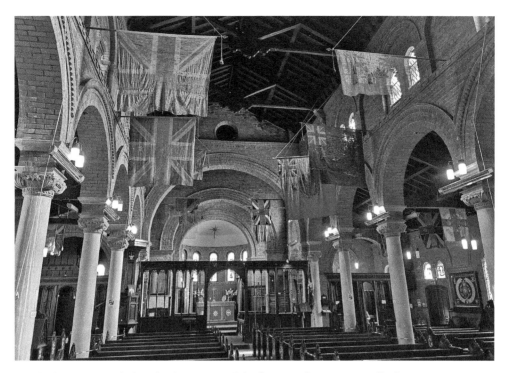

Inside the Regimental Chapel, where many of the former colours are proudly displayed.

From 1880, the 1st Battalion served at home while the 2nd Battalion, still known by their former nickname the 'Pompadours', served overseas. They participated in the Nile Expedition of 1884–85 as part of Sir Garnet Wolseley's 'River Column', which was ultimately unsuccessful in its attempt to relieve General Gordon during the Siege of Khartoum in the Sudan. The Essex Regiment would, however, receive the battle honour 'Nile, 1984–5', which was the first battle honour received since the 44th and 56th amalgamated. During the Second Boer War both regular battalions, the 3rd (Militia) Battalion, and components of the Volunteer battalions served overseas in South Africa in a campaign where disease proved just as lethal as the battlefield. The Essex Regiment received the battle honour 'South Africa, 1899–1902', with the 1st Battalion being awarded the additional honours 'Relief of Kimberley' and 'Paardeberg'. The later engagement is where the fourth Victoria Cross attributed to the Essex Regiment was earned by Lieutenant Francis Newton Parsons.

The First World War saw the British Army expand on an unprecedented scale, and with it the Essex Regiment grew to encompass some thirty-one battalions, of which eleven served overseas and were awarded numerous battle honours. The 1st Battalion served on the Gallipoli Peninsula with the 29th Division, and then in France and Belgium. The 2nd Battalion was sent to France with the 4th Division of the British Expeditionary Force and took part in the retreat from Mons and the Battle of Marne. At the outbreak of war, the 4th through 7th Territorial battalions (1/4th–1/7th), and the 8th (Cyclist) Battalion (1/8th), all formed second (2/4th–2/8th) and eventually third line battalions (3/4th–3/8th). The

The South African War Memorial to the Essex Regiment, Chelmsford.

The 1st Battalion Essex Regiment and the types of dress in use in 1911. (Philip Robey)

1/4th through 1/7th battalions served in Gallipoli, Egypt and Palestine. The 8th (Cyclist) Battalion never served overseas, although many did transfer to battalions in the regiment that did, while the remainder served at home patrolling Essex's coastline. The 9th, 10th, 11th and 13th Service battalions served in France and Flanders. It was during the Battle of Arras in 1917 where the actions of Second Lieutenant Frank Bernard Wearne earned the regiment's fourth Victoria Cross while attached to the 10th Battalion. The remaining battalions raised during the First World War were Reserve battalions and did not serve overseas, with the exception of the 15th (Reserve) Battalion who served in France during the concluding months of the war.

In between the two world wars, the 1st and 2nd battalions went back to their original arrangement of alternating between home and overseas service. The 1st Battalion served at home while also seeing active service in southern Ireland from 1919 to 1921, and then overseas in the French controlled Saarland Province on the France–Germany border in 1934 to 1935 and in Palestine in 1937 to 1938. The 2nd Battalion served in Malta, Egypt and Sudan, seeing active service in Turkey in 1920 and on the north-west frontier of India from 1930 to 1931. Many of the battalions raised before and during the First World War were disbanded after the war had ended. In 1920, the Territorial Force was reformed as the Territorial Army and left the regiment with two Territorial battalions, with former Territorial battalions converted into anti-aircraft defence.

Soldiers of the 8th (Cyclist) Battalion Essex Regiment. (Alan Wicker)

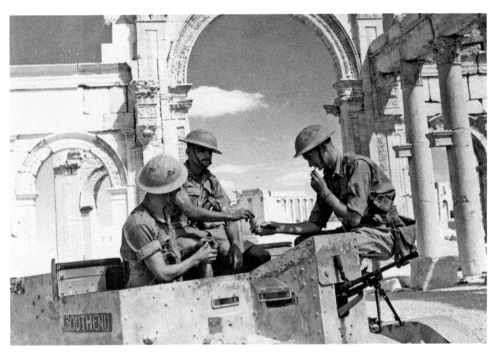

Members of 1st Battalion Essex Regiment on the Bren Carrier 'Southend' in Palmyra, 1941. (Essex Regiment Museum)

During the Second World War the 1st Battalion served in Sudan, Egypt Libya, Syria and Burma. The 2nd Battalion formed part of the 25th Infantry Brigade, which was part of the British Expeditionary Force that were evacuated from Dunkirk in 1940 and would land in 1944 at Gold Beach on D-Day. The two Territorial battalions (the 4th and 5th) expanded to create a second line battalion (2/4th and 2/5th). The 2/4th would remain at home, training and supplying replacements for the regiment. The 5th Battalion's two lines merged and along with the 1/4th served overseas in Palestine, North Africa and Italy. The 1/4th was at the Second Battle of Alamein, while the 5th Battalion served in the North West Campaign and took part in the invasion of Germany. Additional battalions were established throughout the war, including the 7th (Home Defence), 8th and 9th battalions. The 8th Battalion would be transferred to the Royal Armoured Corps and renamed the 153rd (Essex) Regiment Armoured Corps. They continued to wear the Essex Regiment cap badge and would go on to fight in Normandy, while the 9th Battalion was transferred to the Royal Artillery and also served in Normandy.

After the Second World War the 2nd Battalion was disbanded, and its troops amalgamated with the 1st Battalion. In the early 1950s the regiment was stationed in Luneburg, Germany, as part of the British Army of the Rhine, until in 1953 when they served in Korea . The regiment was then stationed in Hong Kong from 1954 to 1956, returning to Germany until 1958 when, at the end of national service, the British Army was reduced and reorganised. The 1st Battalion Essex Regiment and the 1st Battalion Bedfordshire and Hertfordshire Regiment were amalgamated to form the 3rd Battalion

East Anglian Regiment, with most of Warley Barracks passing to the Ford Motor Company for redevelopment. In 1964, the regiments of the East Anglian Brigade amalgamated to create the Royal Anglian Regiment. The 1st Battalion East Anglian Regiment became the 3rd Battalion Royal Anglian Regiment; however. the British Army was reduced in size once again in 1992. The 3rd Battalion Royal Anglian Regiment was disbanded, and its personnel and traditions passed to the Regiment's 1st Battalion.

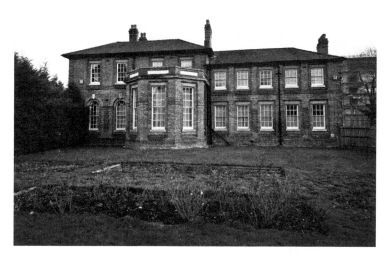

Blenheim House, the former Essex Regiment Officers' Mess, one of the few surviving buildings of the former Warley Barracks.

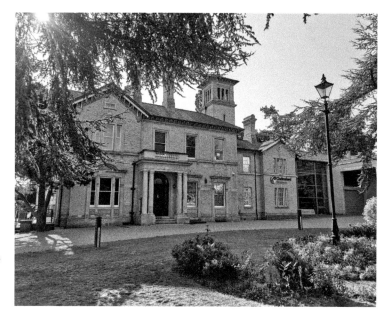

Oaklands House in Chelmsford, home to the Essex Regiment and Essex Yeomanry Museums.

6. Essex and the World Wars

The First World War

During the First World War Essex was a hive of activity. The recruitment and training of soldiers; the transportation of men, munitions and supplies; the construction of new and reinforcement of existing defence positions; and the attacks and battles in the skies above Essex are just a few examples of how the war touched so many lives in the county. The county's existing garrisons and military camps expanded at an unprecedented rate, with new camps established throughout the county to accommodate the ever-expanding armed forces. However, it wasn't just British troops that became a familiar sight in Essex. Allies from Australia, New Zealand and Canada would call Essex their home as they prepared to embark for the Western Front, received specialist training, or recovered from injuries sustained on the front line.

In late 1916, Purfleet became the depot for the newly redesignated Corps of Canadian Railway Troops, and throughout 1917 the 4th, 5th, 8th and 113th battalions, plus No. 85 (Canadian) Engine Crew Company of the Canadian Railway Troops (CRT), were organised and sent from here to the Western Front. As many roads had been destroyed during months of artillery fire, it was determined that the railway was the only practical solution to moving vast quantities of supplies and troops and also became a means of evacuating casualties. From mid-1917 until the end of the war all light railway construction on the Western Front was carried out by the CRT, many of whom passed through the depot in Purfleet.

The Australian and New Zealand Corps (ANZAC) also had a base in Essex from 1916 onwards. Brightlingsea was selected as the location of an Australian Engineers Training Depot, the only ANZAC training facility on the east coast, and the crenelated mansion in Hornchurch (Grey Towers) and its 50-acre park was also a temporary home for many New Zealand soldiers. Purchased for use by the military, a hutted camp was established in the grounds and ready for use by late 1914. At first it was home to the 23rd (Sportsman's) Battalion Royal Fusiliers until they departed in June 1915, and then to the 26th Battalion Middlesex Regiment, who arrived in November 1915 and departed the following month. In early 1916, Grey Towers was selected to be the Command Depot for New Zealand's troops in England, but it was decided that the site was too small and, with wounded New Zealand troops arriving in April 1916, it was decided that Grey Towers would be used as New Zealand's Convalescent Hospital. By the time the New Zealand Contingent left Grey Towers in June 1919 some 20,000 patients had been treated.

At the outbreak of war temporary military hospitals were a familiar feature of Essex town and village life. Over fifty military hospitals were in operation throughout the war and they varied in size, with many auxiliary hospitals operating in private properties offered to the war effort by their owners. In 1914, the British Red Cross and the Order of St John of Jerusalem

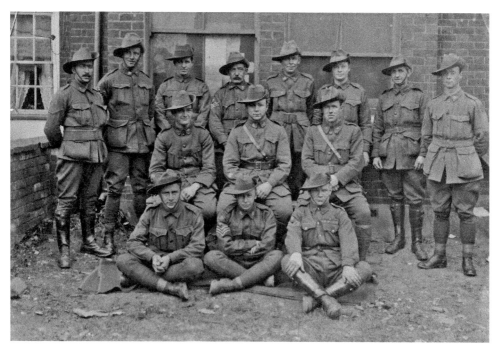

Group of ANZAC engineers stationed in Brightlingsea during the First World War. (Brightlingsea Museum)

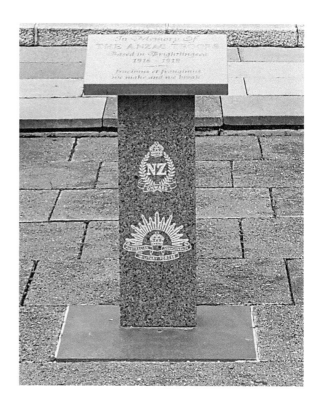

ANZAC memorial at Brightlingsea.
(Brightlingsea Museum)

The entrance to the New Zealand Convalescent Hospital at Grey Towers, Hornchurch.

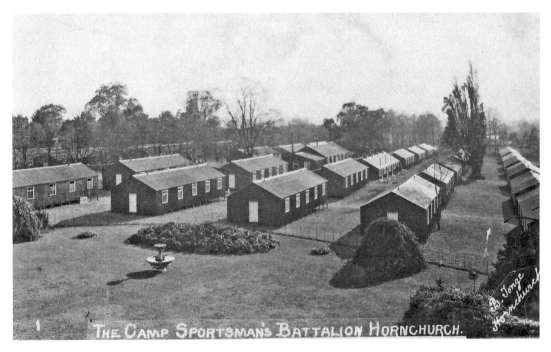

A hutted camp at Grey Towers in Hornchurch. This once housed the Sportsman's Battalion prior to being used by the New Zealand forces as a convalescent hospital.

combined to form the Joint War Committee, pooling their resources to establish auxiliary hospitals that were attached to a central military hospital, such as Colchester. The type of building used for auxiliary hospitals varied, ranging from small private homes and village halls to large hotels and stately homes, with each hospital supported by a team of locally recruited volunteers including those from a local Volunteer Aid Detachment (VAD) who were trained in first aid and home nursing. In Earls Colne, the village hall was utilised as a VAD auxiliary hospital, treating over 1,200 throughout the war; its first patients arriving in 1914 were Belgian soldiers. In May 1915, the Board of Guardians of the Braintree Union Workhouse offered the use of the workhouse board room for use as an auxiliary hospital, known as the Braintree VAD Hospital. The hospital closed in February 1919, having treated 587 patients, performed ten major and seventy minor operations, and registered two deaths. The Braintree Infectious Disease Hospital, which opened in February 1900, had on several occasions between late 1914 and 1916 been used for the bathing of troops and disinfection of their clothing.

Larger auxiliary hospitals included Walden Place in Saffron Walden and Hylands House in Chelmsford. Hylands House opened as a military hospital on 14 August 1914. The owner, Sir Daniel Gooch, offered the house at the outbreak of war and subsequently bore all the expenses of operating the hospital. When the Hylands closed as a hospital in April 1919, over 1,000 wounded British and Belgium servicemen had been treated. It was not only patients who succumbed to their wounds and illnesses at Hylands. In early 1916 the Nurse Hilda Ayre Smith died from septicaemia, believing she had caught blood poisoning from dressing the wounds of a patient. The Saffron Walden VAD Hospital was established in Walden Place, a large house lent for the duration of the war. Opened in April 1915 with fifty beds, it received British, Canadian and Australian servicemen, treating some 1,100 patients before it closed in early 1919.

A group of convalescing soldiers in their 'hospital blues' at Braeside VAD Hospital, Loughton.

Fairview VAD Hospital. This small private home in Chigwell was let by Mr F. Fish in 1915 and had twelve beds for servicemen to convalesce.

The Braintree Union Workhouse boardroom (to the right of the main entrance) was used as a VAD hospital from 1915 to 1919.

Hylands House in Chelmsford, used as a military hospital from August 1914 to April 1919.

In early August 1914, the Admiralty took over the Great Eastern Railway Hotel in Harwich, designating it the Harwich Garrison Hospital, which provided over 120 beds for officers and soldiers. The Admiralty also established HM Queen Mary's Royal Naval Hospital at the Palace Hotel in Southend – the only naval auxiliary hospital in the South East. Although initially intended as a naval auxiliary hospital, the first patients to arrive in October 1914 were wounded Belgian soldiers, followed a few weeks later by men of the British Expeditionary Force. In March 1916, the Admiralty transferred all non-naval patients to other nearby auxiliary military hospitals, such as Overcliff and Glen. During the course of the war, HM Queen Mary's Naval Hospital treated over 4,000 patients.

The First World War introduced the armed force and civilians to a new type of warfare: aerial combat. German Zeppelins first appeared over the skies of Essex in April 1915 and continued throughout the war, either en route to attack London or specifically to attack military and industrial targets in Essex. Later in the war, attacks by Gotha bombers took over from Zeppelins. Anti-aircraft gun positions at Waltham, Thames Haven, Purfleet and Tilbury had a number of successful engagements with Zeppelins over Essex, including the shooting down of Zeppelin L15 on 1 April 1916 by members of the Essex and Suffolk Royal Garrison Artillery at Purfleet and Tilbury Fort. Further successes included the downing of Zeppelin L33 on 24 September, which after dropping its bombs on Bromley-by-Bow and Upminster had been hit by anti-aircraft fire and a Royal Flying Corps (RFC) fighter based at the airfield at Hainault. L33 was forced to land near New Hall Farm in Little Wigborough, where its crew set the airship alight.

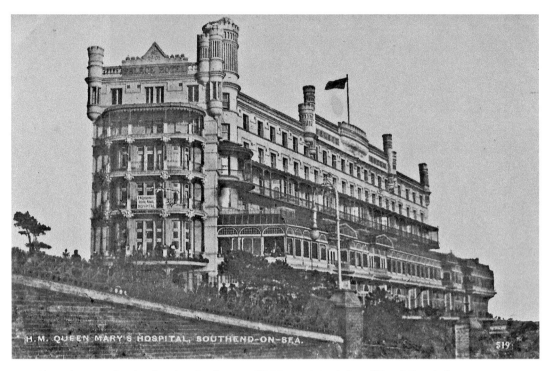

The Palace Hotel at Southend-on-Sea became HM Queen Mary's Royal Naval Hospital.

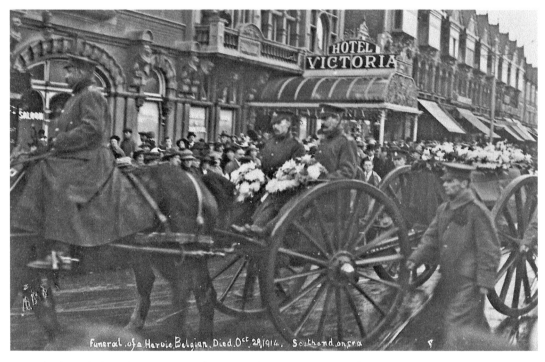

The funeral of a fallen Belgium soldier at Southend-on-Sea, 21 October 1914.

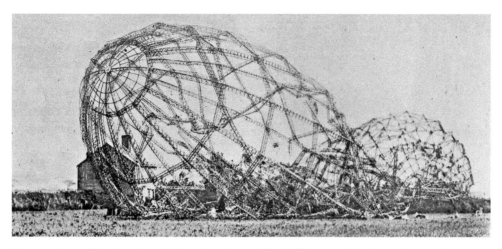

The wreckage of the L33 Zeppelin brought down at Little Wigborough in September 1916.

At the outbreak of war, the RFC, which had only received its royal warrant two years earlier, was initially only used for aerial reconnaissance. With the RFC squadrons busy in France, the Royal Naval Air Service assumed the role of aerial defence at home. Before 1916, there had barely been enough aircraft for service overseas, let along home defence. However, by 1916 aircraft production had significantly increased and the RFC took over from the RNAS, with flying units classified as Home Defence Units. By September 1916, Essex had two Home Defence squadrons: No. 37 Squadron with its headquarters at Woodham Mortimer, and No. 39 Squadron with its headquarters at Woodford. Each squadron had three Flights based at six aerodromes, known as Flight Stations. For No. 37 Squadron, A, B and C Flights had their Flight Stations at Rochford, Stow Maries, and Goldhanger respectively. In July 1917, A Flight moved to Stow Maries and in early August, a new Home Defence Squadron – No. 61 – was established in its place.

For No. 39 Squadron , A, B and C Flights were at North Weald Bassett, Suttons Farm and Hainault Farm. In 1917, all three of these Flights would become part of No. 44 Squadron, stationed at Hainault. It was No. 39 Squadron that had a great deal of success combating enemy Zeppelins. Lieutenant William Leefe Robinson from B Flight shot down Zeppelin SL11 on 2 September 1916, for which he was awarded the VC. Later that same month, Lieutenant Frederick Sowry contributed to the destruction of Zeppelin L32, which came down in flames at Great Burstead, near Billericay, while Lieutenant Wulstan Tempest shot down Zeppelin L31 over Potters Bar in October 1916. For their actions both pilots were awarded the Distinguished Service Order – at that time the second-highest military honour awarded for gallantry.

The explosives and munitions factories established in Essex prior to the start of the First World War continued to produce ammunition for the British Army and Royal Navy. However, it soon became apparent that the quantities required by the armed forces necessitated either additional factories at the current sites, and the conversion of existing manufactures premises in aid of the war effort. Essex had a number of well-established industrial entrepreneurs that offered their factories for producing munitions. Francis

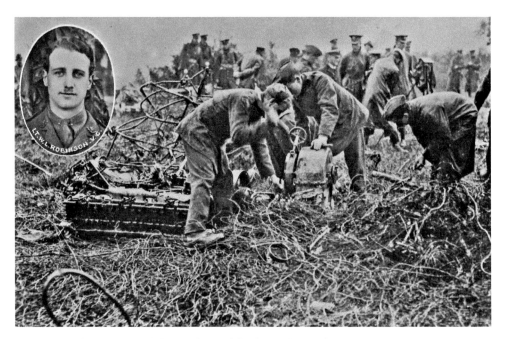

Lt William Robinson VC and the wreckage of the downed Zeppelin SL 11.

Crittall, the manufacturer of steel-framed windows at Braintree ironmongery, co-founded the East Anglian Munitions Committee, a steering a group of forty-two local industries. From 1915 to 1918, the group produced shells and other products for the war effort, with female workers crucially filling the labour shortfall.

In June 1915, the Lake and Elliot factory at Braintree, who were known for manufacturing bicycles and later motorcars, built a new factory for making fuses. Armour grating for warships was also built at the Lake and Elliot factories, which helped save the battleship HMS *Warspite* during the Battle of Jutland. The Warner & Sons Silk Mills in Braintree contributed to the war effort by producing silk used in artillery howitzer cartridge bags that held the explosive charge for large guns; they also experimented with Japanese silk's potential to be used in bullet proof vests for those serving overseas. The Ripper's Joiner Works in Sible Hedingham had experience in manufacturing for the military during Second Boer War in 1899, where it produced sectional wooden buildings and equipment to be shipped to South Africa. During the First World War, Ripper's would go on to manufacture wooden propellers and instrument panels for aeroplanes, various equipment for other munition factories, and wooden huts used as men's quarters at Flight Stations in Essex, East Anglia and as far as Wales.

In Colchester, Messrs Davey, Paxman & Co. Ltd, often simply referred to as Paxman's, were well known for manufacturing steam engines and boilers before the war. Paxman's was one of three companies entrusted with the Admiralty's secret work in connection with submarine warfare. The company continued to produce its pre-war products, boilers and engines, which were in constant demand by the Admiralty and the War Office. However, Paxman's also produced numerous types of munition, including submarine

mine destructors known as paravanes; various types of quick-firing guns; parts for submarine engines; submarine mines and sinkers, counter mines and electronic contact mines; depth charges and over 250,000 shells. By the end of the war, female workers accounted for almost a third of the Paxman's 1,500 workforce, receiving training to operate shell lathes and other specialist equipment.

One of the most pioneering industries associated with Essex is Marconi's Wireless Telegraph Company, which in 1912 established the first purpose-built wireless factory at New Street, Chelmsford. Guglielmo Marconi was credited with the development of wireless signals as a practical communication system, which was first used by the army during the Second Boer War and the Royal Navy at the turn of the twentieth century. At the outbreak of war in 1914, the Marconi New Street Works in Chelmsford was taken over by the Admiralty, who placed the factory under immense pressure to meet the needs of the rapidly expanding armed services. The talented senior engineer at Marconi's, Mr H. J. Rounds, was seconded to Military Intelligence, where he developed the Bellini-Tosi Direction Finder (D/F) at Chelmsford. He was sent to the Western Front in December 1914 and in January 1915, weekly maps were produced based on D/F information for Military Intelligence. These maps allowed the British to track German troops' positions by tracking the movement of their wireless positions. The success of Rounds' work on the Western Front led to the Admiralty installing a chain of stations at home using the equipment manufactured at Marconi's Chelmsford factory, providing home defence units on the bearing of enemy submarines and Zeppelins.

Marconi's New Street Works in Chelmsford. The façade is original, while the interior has been redeveloped.

The Second World War

Following the declaration of war in September 1939, the war seemed distant and relatively unobtrusive for many in Essex who were not serving with His Majesty's Forces. This was to change on the night of 30 April 1940, when a damaged German Heinkel 111 mine-laying plane crashed in Victoria Road in Clacton-on-Sea and local residents Mr and Mrs Gill became the first two civilian fatalities of the war on mainland Britain. The following month – May 1940 – German forces invaded the Low Countries and subsequently swept across France, forcing the British Expeditionary Force (BEF) to the beaches of Dunkirk.

After the evacuation of Allied troops from Dunkirk in 1940, and with only the English Channel standing between Britain and an expected German invasion, a series of coastal and inland defences were established throughout Britain. Given its large coastline, flat landscape and open terrain, it was feared that Essex could provide the ideal terrain for a swift attack towards London. To defend against what was deemed an inevitable threat, a series of lines of defence known as 'stop lines' were established. These stop lines were intended to prevent or delay enemy inland advance until heavy weapons and additional troops could be deployed. There were three major stop lines running through current and former boroughs of Essex: the Outer London Line A, the General Headquarters (GHQ) Line and the Eastern Command Line. Stop lines utilised natural barriers such as rivers, woodland, and marshes. To fill in the gaps between these natural features, anti-tank ditches were dug up to 7 metres across. Along the line a series of infantry, artillery and anti-aircraft pillboxes were spaced out at regular intervals and supplemented with concreate anti-tank cubes and triangular 'dragon teeth'.

Brick-built pillbox at Wat Tyler Country Park, Pitsea. Some 400 pillboxes were built along the GHQ Line in Essex, over 100 of which survive to the present day.

The GHQ Line was the longest of all the stop lines in Britain and was regarded by General Ironside as the most important. If German forces managed to break through coastal defences and secondary stop lines, it was intended that the GHQ Line would be the final line of defence before the enemy engaged the London defences. In Essex, the GHQ Line ran northwards from Pitsea Marsh to Great Chesterford, just north of Saffron Walden. The Eastern Command Line (initially a smaller local stop line to protect Colchester, but later expanded to become an additional defence line between the coastal defences and the GHQ Line) ran from Wivenhoe, following the River Colne, past Colchester westwards, and then into to Suffolk. The River Colne provided an ideal anti-tank barrier up to the Chappel Viaduct, near Chappel & Wakes Colne railway station. While the railway embankment to the north provided a natural anti-tank barrier, it was crucial that the junction of road, river and rail beneath the viaduct was defended. The Chappel Viaduct was therefore designated a Nodal Point and given all-round defences, manned by the 8th Battalion Essex Home Guard. The grouping of defensive measures at Chappel included artillery, infantry and anti-aircraft pillboxes, anti-tank cubes and concrete cylinders, and spigot mortar emplacements. The surviving concrete cylinders that lie among the anti-tank cubes originally lay on the riverbed, making it impossible for the enemy to navigate the river.

During the Second World War entire areas of the Essex coastline were requisitioned and placed out of bounds to civilians. At the outbreak of war, Southend Pier – famous for being the longest pleasure pier in the world – was requisitioned by the Admiralty and

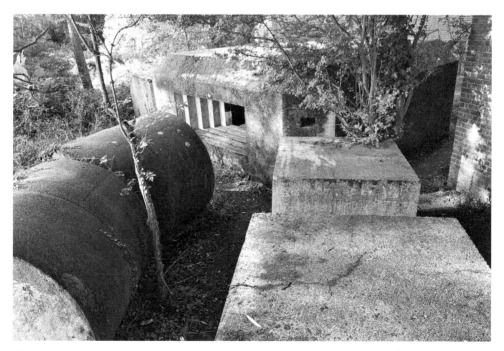

The defensive structures at Chappel represent the survival in a single grouping of the whole range of defensive structures that were deployed along the Eastern Command Line.

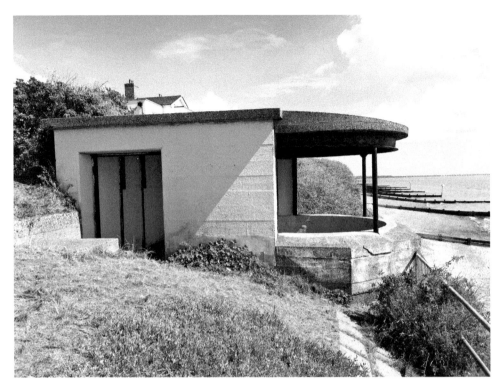

A Second World War searchlight emplacement along the sea wall at Shoeburyness.

designated HMS Leigh. The pier provided a mustering point for convoys and was in the ideal position for the navy to organise shipping movement in the Thames. It remained under the navy's control until the end of the war.

HMS Leigh is associated with one of the most dramatic and inspiring events from the early stages of the war. On 26 May 1940, there was a plan to evacuate the trapped BEF along the coast of Dunkirk, codenamed 'Operation Dynamo'. The naval commander of HMS Leigh sent out a request for small shallow draft vessels to come to the aid of the stricken men. Those who answered the call included were six cockle boats from Leigh-on-Sea, who made their way to Southend Pier to be supplied for the journey across the Channel. The boats (*Endeavor, Letitia, Defender, Reliance, Renown* and *Resolute*), along with their crews, left HMS Leigh for Dunkirk at 12.30 a.m. on 31 May 1940, arriving early the next morning. The *Endeavour* and *Letitia* suffered damage to their rudders as at times they sailed too close to the shore, while the *Renown*'s engineer broke down. All had to be towed back to England. These little boats from Leigh knew the risks but still rescued many, though this was not without sacrifice. While being towed home the *Renown* hit a mine at approximately 1.50 a.m. on 1 June, killing the ship's four crewmen. The Southend area is also home to a piece of Second World War ingenuity. Located off the coast of Thorpe Bay, a section of a Mulberry harbour for use during the D-Day landing began to leak while being transported. As the section flooded, it settled in its current position on a sandbank and broke into two pieces.

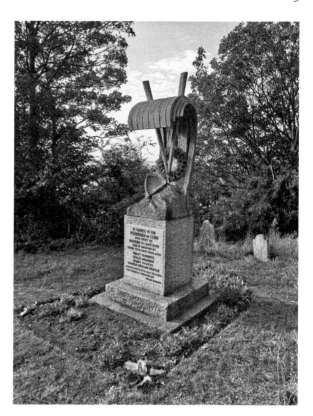

A memorial to the fishermen from Leigh-on-Sea who went to aid the soldiers trapped on the beaches of Dunkirk at St Clement's Churchyard, Leigh-on-Sea.

As with the First World War, throughout the course of the Second World War private property and land were either willingly made available by their owners in support of the war or were temporarily requisitioned by the government. These properties were used by the government in various ways, and while some empty houses were requisitioned to billet soldiers or land used to build additional airfields, others were used for more clandestine operations. Hylands House and estate in Chelmsford, which had been offered for use by the Gooch family during the First World War, was once again offered by its current owner Christine Hanbury. The estate was the site of a German prisoner-of-war camp, along with a wireless command post for the 6th Anti-Aircraft Division. While Christine remained in the house, occupying the upper floors, in 1944 the ground floor and basement became home to the headquarters of the relatively new Special Air Service (SAS). The SAS had become known for its tough training methods, dangerous and heroic missions, but at Hylands House it was better known for its more mischievous activities. On one occasion, Paddy Mayne, the decorated commanding officer of the 1st SAS Regiment, attempted to drive up the house's grand staircase for a bet. The jeep would later have to be dismantled before it could be removed. Hylands House remained the headquarters of the SAS until it was disbanded in October 1945.

Marks Hall, the Jacobean mansion located between Colchester and Braintree, was first requisitioned in 1941. It became home to units of the Eighth and Ninth US Army Air Force (USAAF) until 1944 when it became the headquarters of the Royal Air Force's 38

A memorial to the RAF and USAAF units that served at the airfield on the Mark Hall estate at Earls Colne. The memorial features a propellor from a B17 Flying Fortress.

Group, which provided support for Special Operations Executive (SOE) missions. 38 Group's aircraft also towed gliders across the Rhine as part of Operation Varsity on 24 March 1945, the last Allied airborne operation of the Second World War. Near Saffron Walden another Jacobian mansion, Audley End House, was requisitioned and used by the SOE in 1942 for training in ungentlemanly warfare. Designated Special Training School 43, or simply 'Station 43', it became the headquarters of the Polish Section. Those Polish men and women who were resourceful, physically and mentally tough enough to pass the special training here, and over 500 did so, often returned to Poland to coordinate local resistance to the occupying German troops. This was incredibly dangerous work, but many would never put their training into action, as they were killed when their aircraft were shot down or when parachutes failed. The Polish section left Station 43 in December 1944, relocating the Italy as it was a shorter flight to Poland.

Once again, Essex industry played an important role in providing munitions for war; many were the same companies that came to the assistance of the government during the First World War. In Colchester, Paxman's continued to produce engines for the Royal Navy, though now diesel rather than steam. In Chelmsford, Marconi produced transmitters and receivers and constructed radar towers at Canewdon, Dengie and Great Bromley as part of the Chain Home (CH) radar system, providing the RAF with an early warning about incoming enemy bombers. Naze Tower at Walton, originally having been used as a sentry position to survey the Orwell Estuary during the First World War, became a radar tower with operators stationed in the tower and a Chain Home Low (CHL) radar dish installed

The Polish SOE memorial at
Audley End.

on the roof. The CHL enabled the RAF to detect enemy aircraft approaching at altitudes
below the detection capability of the original CH radar towers.

The Hoffmann Manufacturing Company, also based in Chelmsford, produced ball
bearings for British aircraft, military vehicles and other equipment during the First
and Second World Wars. Due to their strategic importance, both of these factories were
attacked during the course of the Second World War, initially by enemy aircraft and
later by German V-1 and V-2 flying bombs. As the Allied forces pushed the German V-2
bomb launchers out of range from attacking London, Essex would bear the brunt of these
attacks. In the early hours of 19 December 1944, Chelmsford suffered its greatest loss of
life from a single wartime incident when a V-2 bomb exploded near the western edge
of the Hoffmann factory. The explosion caused significant damage to the factory and to
houses along Henry Road, causing the death of thirty-nine men and women and injuring
138 others.

The Crittall factories in Braintree, Witham, Silver End and Maldon also gave themselves
over to munitions production, with the Witham factory producing Bailey Bridges for the
Royal Engineers. In Dagenham, the Ford automotive factory, which opened in the early
1930s, produced a variety of trucks and other vehicles such as the Universal Carrier – a
light armoured tracked vehicle used to transport troops and equipment, and armed with
a Bren gun.

The Marconi Chain Home Tower at Great Baddow. Originally erected at RAF Canewdon in 1937, it was relocated to Great Baddow in 1956.

Globe House in Chelmsford, formerly the home of the Hoffmann Manufacturing Company.

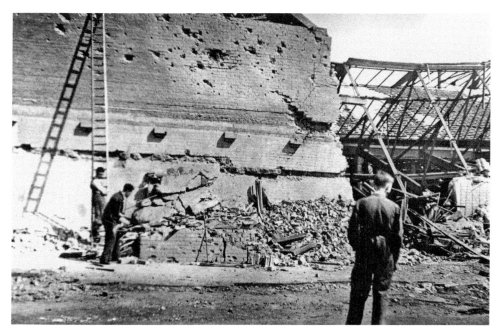

Bomb damage to the Hoffmann Manufacturing Company factory in Chelmsford. A memorial for those who lost their lives during the Luftwaffe bombing raids on Hoffmann's can be found at Chelmsford Cemetery. (Chelmsford Museum)

During the course of the war, twenty-three airfields were constructed across the county. Some of these airfields were existing RAF airfields or had been RFC aerodromes and landing grounds during the First World War; others were private airfields requisitioned by the government or were purposely built for the war. RAF Rochford, North Weald, Hornchurch (Sutton Farm) and Fairlop (Hainault Farm) were all former sites of First World War aerodromes.

As with the First World War, Essex airfields would play an important role in defending the skies. Not only during the Battle of Britain against German bombers but also earlier during Operation Dynamo. During this operation the RAF squadrons based at Essex airfields (flying the famous Hurricane and Spitfire fighters) had ensured many German bombers never made it to the shores of Dunkirk. They then harassed the enemy fighters that did make it, who were strafing the Allied troops on the beaches. At RAF North Weald various squadrons made up from foreign nationals, including Czech and Polish pilots, flew alongside the British Allies. Prior to the USA joining the war in 1941, American pilots volunteered to serve in the RAF, forming the American Eagle Squadrons, which flew Spitfires from Essex airfields including RAF North Weald and Rochford. When America entered the war, the Eagle Squadrons in the England were absorbed into the Eighth USAAF, and RAF North Weald became home to Norwegian squadrons.

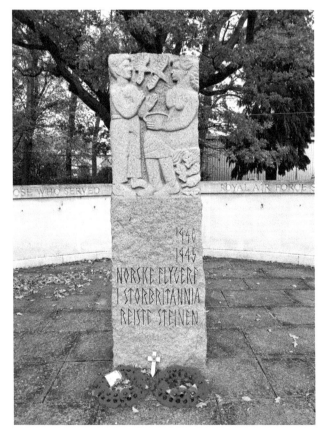

A memorial to the Norwegian airmen who served at North Weald airfield.

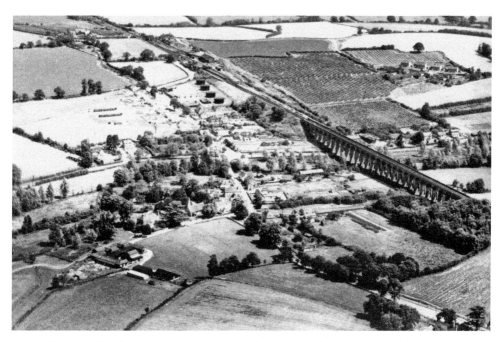

An aerial view of the Chappel viaduct and Chappel & Wakes Colne station. The former Second World War POL depot storage tanks were located on the north side of the viaduct. These were removed in the mid-1970s. (East Anglian Railway Museum)

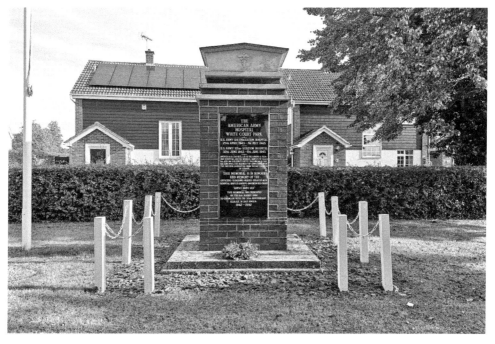

A memorial to the former USAAF Hospital at Braintree at the entrance to the White Court residential development.

During 1942 the first American airmen of the USAAF began arriving in Essex, which soon led to thousands more occupying sixteen airfields across the Essex countryside, often affectionately known as the 'Friendly Invasion'. Support facilities, including a petrol, oil and lubricant depot at Chappel & Wakes Colne station, a forward ammunition depot at Bures, and American Army hospital near Great Notley were also established in Essex. These airfields and the small villages they were built close to became home for airmen of the Eighth and Ninth USAAF, and it was not uncommon for the same airfield to have RAF, Eighth and Ninth USAAF units stationed there at various times throughout the war. An area near the village Ridgewell was selected as a location for a new heavy bomber airfield, and by late 1942 the Class A heavy bomber airfield RAF Ridgewell was ready to receive its first occupants – RAF No. 90 Squadron's Short Stirling heavy bombers. No. 90 Squadron left Ridgewell in late May 1943, and in its place came 2,000 servicemen of the Eighth USAAF, 381st Bombardment Group (BG), in early June. Redesignated Station 167, the 381st BG flew arguably one of the most iconic bombers of the Second World War from Ridgewell: the B-17 Flying Fortress. Between June 1943 until the 381st departed Ridgewell two years later, the Bomber Group completed 297 missions over France, Germany, Belgium, Holland, Norway, Luxembourg, Poland and Czechoslovakia, where the target was the Skoda Works at Pilsen. From the 346 Flying Fortresses that were assigned to Ridgewell, 165 were lost. In July 1945, the airfield was transferred back to the RAF, where No. 94 and No. 95 Maintenance Units were responsible for storing and disposing of ordnance until 1955. It was finally decommissioned in 1957.

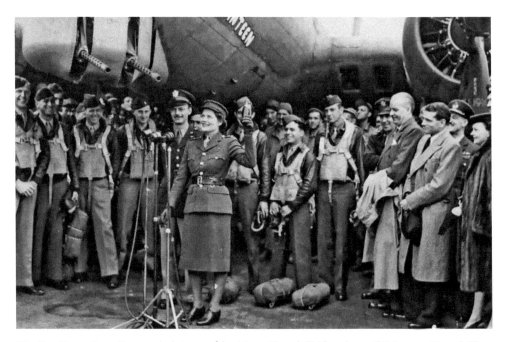

The B17 'Stage Door Canteen', christened by Mary Churchill (daughter of Winston Churchill) at USAAF airbase at Ridgewell in April 1944. Hollywood actors Lawrence Olivier and Vivien Leigh were also in attendance. (Ridgewell Airfield Commemorative Museum)

The Ridgewell Airfield Commemorative Museum, housed in part of the former airfield hospital. A memorial to the twenty-four men who died when bombs being loaded onto the B17 *Caroline* exploded at the airfield can be found near the museum, along the airfield's old perimeter track. (Ridgewell Airfield Commemorative Museum)

7. Post-Second World War to Present Day

In the years after the Second World War, Essex's military heritage has predominantly been shaped by two events: the decades of global tension that defined the Cold War era and the gradual, but continuous, reduction of the British armed forces.

In the years that immediately preceded the Allied victory during the Second World War, the conflicting ideologies of the Western Allies and the Soviet Union became apparent and nuclear conflict seemed increasingly likely. Defences in Essex were built in preparation against potential Soviet attacks. At Shoeburyness, an anti-submarine boom ran from East Beach to the far side of the mouth of the Thames Estuary at Sheerness in Kent. This replaced an earlier wooden naval boom built during the Second World War to restrict traffic along the Thames. The Cold War boom was built between 1950 and 1953, and was made from concrete piles and linked by metal straps with a gap in the boom that would be closed by moored Royal Navy vessels when required. The usefulness of the boom was short-lived because by the mid-1950s jet-powered aircraft and rockets with nuclear meant an attack from a distance far more likely. In the 1960s, the section of the boom on the Kent side was removed and the section on the Essex side was reduced to just over 2 kilometres.

In 1952, RAF Special Operations Centres (SOC) were built along the east coast of the country, codenamed ROTOR, utilising the existing Chain Home communication network built during the Second World War. Each SOC was a bunker built with reinforced concrete, 10-foot-thick walls and a 14-foot-thick roof. It had a steel blast-proof door and its own water tanks and generators making it self-sufficient, allowing the occupants to survive a nuclear explosion. The function of the SOC was to collect all available information and transmit evaluations to Fighter Command and the nearest Ground-Controlled Interception (GCI) radar station. At Kelvedon Hatch, a three-level underground SOC bunker was built between 1952 and 1953, controlling the metropolitan area. The entrance to the bunker was an unassuming bungalow, which acted as the bunker's guard house. The usefulness of the SOC was short-lived as improvements in radar technology meant that the GCI stations no longer required the assistance of the SOCs. However, in preparation for the continuance of national and local government, various SOC and other nuclear bunkers were converted into administrative centres for regional seats of government, with Kelvedon Hatch becoming the headquarters for the London region. From the bunker, advice and instructions could be passed to those who survived the nuclear attack, using the BBC studio to transmit this information. The bunkers' facilities were maintained until the fall of communism and the Soviet Union in the late 1980s.

The advances in global military technology meant that many of the Second World War defensive structures built in Essex had no future, at least for military purposes. The Maunsell forts, built in 1942 off the coast of Harwich and in the Thames Estuary

The Cold War defensive boom at Shoebury East Beach marks the western boundary of the firing range at the MoD establishment managed by Qinetiq.

The 'secret' nuclear bunker at Kelvedon Hatch. It is open to the public to explore the three lives of the bunker. (RAF ROTOR Station, Civil Defence Centre and Regional Government HQ)

between Shoeburyness and Sheerness for the Royal Navy and British Army, are an interesting example of wartime defences adapted for use by civilians. The forts were all decommissioned by the late 1950s, and while several have either been dismantled or collapsed due to storm damage and ship collisions, two of the forts that survive today have been used in interesting ways. The naval Manusell fort known as Rough Sands, built 6 miles off the coast near Harwich, was purchased in 1967 by Patrick Bates and established as an independent state – the Principality of Sealand, which is not recognised by any sovereign state. Rough Sands, along with another naval Maunsell fort, Knock John, were used to broadcast the pirate radio station Radio Essex.

By 1946, the airfields scattered across Essex for the most part returned to agricultural use, with the USAAF base at Wethersfield and RAF North Weald being the only operational military post-Second World War airfields. Wethersfield was initially allocated to the Eighth USAAF, but it ultimately served the Nineth USAAF 416th Bomb Group (Light) and later the RAF, with flight activities ceasing at the end of the war. In the early 1950s the airfield became operational again with the arrival of US Air Force (USAF). Over the years several US units served here, including various US Fighter-Bomber Wings with nuclear capabilities and Lockheed U-2 'spy planes', until 1991 when it became the MoD Police HQ and training centre. North Weald continued to be used by the RAF after the Second World War, with the airfield receiving extensions to the runways and a new control tower, which was built in the early 1950s. In 1953, North Weald became home to a squadron of Hawker Harriers, No. 111 Squadron, with its aerobatic display team the 'Back Arrows', the predecessor to the current RAF Red Arrows Display Team. No. 111 Squadron left North Weald in 1958, ending its use as an operational military airfield, and is now used by civilian light aircraft along with the Essex and Hertfordshire Air Ambulance, who also operate from another former Second World War airfield at Earls Colne.

While other airfields ceased military operations after 1946, many were still retained by the RAF and USAF for other purposes. The buildings at Ridgewell and Great Dunmow were used as USAF store depots until the 1960s. Hornchurch was used as the RAF Aircrew Selection Centre between 1952 and 1962, when it was transferred to Biggin Hill. At Stansted, the Ministry of Aviation Fire Training School was established in 1960, and the former military airfield has expanded extensively as it is now London Stansted Airport, while the former airfield at Rivenhall was used as a test site for Marconi radio equipment. The former RAF and USAAF airfield at Debden has had many military uses since the end of hostilities, including as a RAF Technical College and RAF Police School, until in 1975 when the British Army took over the site and it was renamed Carver Barracks.

As the British Army became much smaller after the Second World War, so did their presence in Essex's towns and villages. However, despite the closure of Warley Barracks in 1958 and the Shoebury Garrison Headquarters in 1976, new units have not only arrived but have become part of the identity of many Essex communities. At Carver Barracks, after stays by various armoured reconnaissance regiments, the Royal Engineers arrived in 1993. Carver Barracks has remained the home two Explosive Ordnance Disposal (EOD) units, 33 Engineer Regiment (EOD) and 101 (City of London) Engineer Regiment (EOD), each being honoured with the freedom of the borough of Uttlesford in 2009 and 2011

The North Weald airfield type 5223a/51 control tower built in 1952.

The entrance to Carver Barracks, the former RAF airfield near Debden.

The redeveloped Artillery Barracks stables with accommodation above.

respectively. Although the Shoebury Garrison HQ closed in 1978, the garrison's Victorian buildings and the Old Ranges have since been redeveloped as private housing and, adjacent to Gunners Park, a local nature reserve. The New Ranges, established in the 1890s to the north-east of the village including Foulness Island, is now the site of MoD Shoeburyness. Operated by QinetiQ, MoD Shoeburyness is a defence Test and Evaluation (T&E) site for the training and support services of munitions, which includes the disposal of old ammunition and explosives, as well as EOD training.

In Colchester, many of the Victorian garrison buildings have been demolished or converted to private residencies and for other civilian uses; however, the town still has a wide military footprint. During the late 1950s it became the home to the 3rd Infantry Division, and later the 19th Independent Infantry Brigade. In 2004, Merville Barracks became the headquarters of the 16th (Air Assault) Brigade, an independent rapid-response formation that includes the 2nd and 3rd battalions of the Parachute Regiment, which arrived from Aldershot in 2000 supported by airborne artillery, engineer, signals, medical and logistic units. Kirkee and McMun Barracks, built in the 1930s, and Roman Barracks built in 1962, have been incorporated into the space that Merville Barracks occupies. Goojerat Barracks was rebuilt between 1970 and 1975 and is the home of 156 Provost Company, Royal Military Police, and the airborne unit attached to the 16 Air Assault Brigade. Both units have been honoured with the freedom of the borough of Colchester – 156 Provost Company in 1998 and 16 Air Assault in 2008. The site of an emergency barracks built in 1939, known as Berechruch Hall Camp, which later held Italian, German

Cavalry Barracks stables with accommodation above awaiting redevelopment.

Goojerat Barracks in Colchester, home to 156 Provost Company Royal Military Police.

and Austrian prisoners of war, is today the Military Correction Training Centre (MCTC). The MCTC was built in the late 1980s in Colchester Garrison area; it is the only military detention centre in the country and holds service personnel from all three branches of the armed forces.

The Army Reserve Centre in Warley, home to 124 Transport Squadron Royal Logistic Corps.

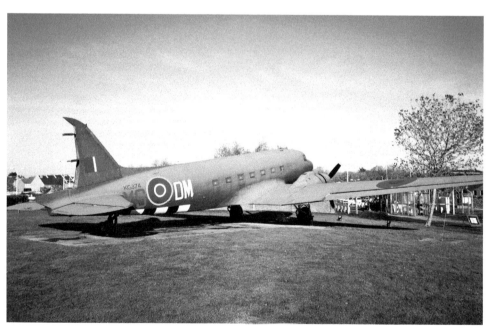

The Dakota Gate Guardian at the entrance of Melville Barracks in Colchester with its tail rudder removed for restoration work to be carried out.

8. Military Personalities: Gallant, Distinguished and Disgraced

Many people associated with Essex by birth, education, regimental affiliation, or residing in the county during their lifetime have distinguished themselves through acts of gallantry, selflessness, or faithful service. However, there are those who had a more chequered military career. A number of recipients of gallantry awards have already been referenced in earlier chapters. There are many more stories (both military and civilian) worthy of mention, and while some may have been covered in other publications, they still deserve recognition here. Such notable individuals include Field Marshal Sir Evelyn Wood, born in Cressing (near Braintree) who, for his bravery at Sindwaho (India) in 1858, was awarded the Victoria Cross (VC). In 1886, placed in charge of Eastern Command in Colchester until January 1889, he would later be appointed Deputy Lieutenant of Essex in 1896 and bestowed the freedom of the borough of Chelmsford in 1903. Another of Essex's VC recipients, Boy (Class 1) John Travers Cornwell, was born in Leyton. He is the youngest of Essex's VC recipients, and the third-youngest recipient in the country to date at the age of sixteen years and four months. He was awarded the VC for his bravery during the Battle of Jutland on 31 May 1916, when he remained at his post on HMS *Chester* in an exposed position throughout the battle, while those around him were either dead or mortally wounded. When the Chester retired from the battle, Cornwell was still at his post, with steel shards penetrating his chest. He died of his wounds in hospital on 2 June 1916.

Essex has a number of VC recipients, including Herbert Columbine, who lived at his family home in Walton-on-the-Naze prior to his enlistment with the Royal Hussars in 1911 and eventual service with the Machine Gun Corps (MGC) during the First World War. Columbine was killed in March 1918 at Hervilly Wood in France, defending his position against waves of enemy assaults. His last words to his comrades were reportedly 'save yourselves, I'll carry on' before he and his gun were hit by enemy bombs. Harold Mugford, a member of the Essex Yeomanry, arrived in France in November 1914 and served in a machine gun attachment of the Essex Yeomanry. Transferring to the MGC in March 1916, Mugford was awarded his VC for his actions at Monchy-le-Preux on 11 April 1917. In an exposed forward position and severely wounded, Mugford continued firing his machine gun, even when his position was struck by a shell that broke both of his legs. He remained in his position, instructing his comrades to leave him and to take cover. Surviving the attack, Mugford's injuries included shrapnel to his arm, hip, tongue and jaw, and both of his legs were amputated below the knee. Finally, Lieutenant Colonel Augustus Charles Newman, known as 'Charlie' by his men, initially served in the ranks of the 4th Battalion Essex Regiment in the mid-1920s. At the outbreak of war in 1939 Newman was commissioned and was later attached to No. 2 Commando. He was awarded the VC for his bravery and leadership during Operation Chariot, attacking the dry dock held by the Germans at the French port at St Nazaire in March 1942. Newman and his men successfully held off attacks from a superior force until the demolition parties had completed their work, putting the dry dock permanently out of use.

Field Marshal,
Sir Evelyn Wood.

Essex-born Field Marshal Sir Evelyn Wood VC, in charge of Eastern Command, Colchester, 1886–89.

Lieutenant Colonel Augustus Charles Newman, Essex Regiment attached to No. 2 Commando, took part in Operation Chariot for which he was awarded the Victoria Cross. (Essex Regiment Museum)

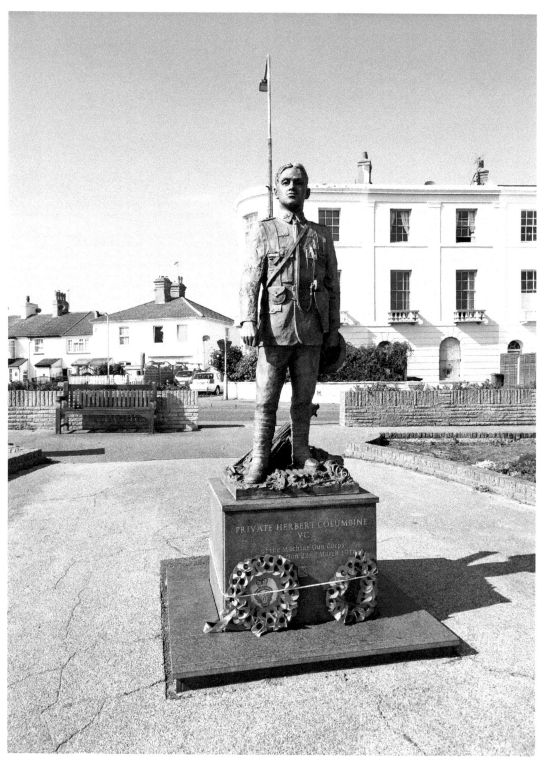

The memorial to Henry Columbine VC on the Parade, Walton-on-the-Naze.

While there have been many gallant deeds by men on the battlefield, the contribution made by nurses in wartime was equally heroic and yet rarely receives enough attention. Kate Evelyn Luard is one such nurse whose service receives less recognition than other, higher-profile nurses who served between 1914 and 1918. Kate Luard was born in 1872 in Aveley, near Thurrock, where she spent her childhood years. Between 1887 and 1890 she attended the Croydon High School for Girls, whose headmistress and founder Dorinda Neligan (a suffragette and nurse during the Franco-Prussian War of 1870) no doubt strongly influenced Luard's future. Upon leaving school, Kate took various jobs to raise money to attend the nurse-training school of Kings College Hospital. In 1900, she served for two years with the Army Nursing Service in South Africa during the Second Boer War, returning home after the war to continue her nursing work. Two days after war was declared, on 4 August 1914, Luard enlisted in the Queen Alexandra's Imperial Military Nursing Service Reserve and was soon serving on the Western Front: at first on ambulance trains and then in casualty clearing stations. Working under trying conditions in the most forward medical units, as close to the front as a women could get, her personable nature, composure and dedication to her patients resulted in the awarding of the Royal Red Cross First Class. Luard also received a bar for a second award and was twice mentioned in despatches for her gallant and distinguished service in the field. In her later years, Luard returned to Essex to live with two of her sisters in Abbotts, Wickham Bishops. Kate Luard died in 1962 at the age of ninety and is buried at St Bartholomew's Church in Wickham Bishops.

The Felsted School, founded in 1564, is one of many private schools in Essex whose alumni have had distinguished careers in the military. Notable 'Old Felstedians' include VC recipients Lieutenant Richard Hamilton for his conduct with the Corps of Guides (Cavalry) during the Second Afghan War, and John Leslie Green, who was killed during the first day of the Battle of the Somme in 1916 while rescuing an injured officer under heavy enemy fire. However, one of Felsted's former students, Henry Leslie Hulbert, would go on to be awarded the United States of America's highest military decoration of gallantry: the Congressional Medal of Honor. Hulbert entered the British Colonial Civil Service after finishing his schooling at Felsted. His first appointment was in Malaya where a personal scandal resulted in his divorce. Leaving Malaya in disgrace, he chose to travel to the United States. At thirty-one years old, Hulbert enlisted in the US Marine Corps in 1898, and in April 1899 his distinguished conduct in the presence of the enemy while serving with the Marine Guard, USS Philadelphia, during the Second Samoan Civil War earned him the Congressional Medal of Honor. His career after the being awarded the Medal of Honor was equally distinguished. In early 1917, now fifty years old and holding the warrant rank of Marine Gunner, Hulbert volunteered for foreign service with the American Expeditionary Force and served with the 5th Regiment (Marines), 2nd Division. Between June and October, he was cited four times for bravery, including carrying out single-handed attacks on machine gun positions at Belleau Woods, and was awarded the Distinguished Service Cross the Navy Cross (posthumously). His courage and leadership skill earned him a commission before he died on Blanc Mont Ridge on 4 October 1918 at the rank of captain, leading from the front.

Portrait of Henry Lewis Hulbert as a sergeant major wearing his Medal of Honor.

The grave of the Medal of Honor recipient
William Oakley at Wivenhoe Cemetery.
(Philip Robey)

Further Congressional Medal of Honor recipients linked to Essex include Chief
Gunner's Mate William Oakely, US Navy, and Colonel James Howard, USAAF. During
the American-Spanish War, serving as a Gunner's Mate Second Class, Oakley showed
extraordinary heroism in action while under heavy fire from the enemy in action on
board the USS *Marblehead* during the operation of cutting the cable leading from
Cienfuegos, Cuba, on 11 May 1898. His display of exceptional bravery and coolness
throughout this period earned him the Medal of Honor. Colonel Howard was stationed
at the US Airfield in Boxted with the 345th Fighter Group of the Nineth USAAF during
the Second Ward War. On 11 June 1944, the 364th were escorting the 401st Bomber
Group when Howard became separated from the rest of his squadron. During his flight
he spotted some thirty to forty German fighters heading for the American bombers.
He engaged the enemy who in turn broke off their attack and now targeted Howard.
Reports by the pilots of the 401st confirmed Howard had destroyed at least six enemy
aircraft and damaged others, and recommended him for the Medal of Honor that he
ultimately received.

There are as many who did not receive a gallantry award, but whose distinguished
service and gallant conduct is worthy of mention. One example is Lieutenant General
James Oglethorpe, whose connection with Essex would come much later in life when
he acquired, by marriage, Cranham Hall, which became his home for over forty years.
Oglethorpe may be best known for his founding of the colony of Georgia in America;

however, he was also an experienced military leader, first serving in Queen Anne's 1st Regiment of Foot Guards in 1710 before gaining combat experience during the Austro-Turkish War (1716–18) with the Austrian Imperial Army. In 1737, Oglethorpe raised an army, the 42nd Regiment of Foot (Oglethorpe), and his army defeated Spanish attacks on the colony of Georgia, and later served during the Jacobite Rebellion.

GENERAL OGLETHORPE.

James Oglethorpe, founder of the colony of Georgia. (Godalming Museum)

Cranham Church, the burial place of James Oglethorpe.

In the small village of Gestingthorpe, the Georgian manor Overhall, more commonly known as Gestingthorpe Hall, was once the family home to soldier and explorer Lawrence Oates. Born 1880 in Putney, Lawrence moved to his new home in June 1891. At the age of twenty, Oates' love of horses helped steer him into a commission with the cavalry regiment, the Inniskilling Dragoon. In December 1900, Oates arrived in South Africa with a detachment of his regiment, and was soon engaged in local skirmishes with the Boers. Having recently been promoted to lieutenant, he joined the column under Colonel Pearson that was making its way to the relief of Aberdeen, Cape Colony. It was during the following action that Oates earned the nickname 'No Surrender Oates'. When the column faced attack from Boer commandos, Oates was selected to lead fifteen men in a patrol to draw the enemy's fire. Oates and his men soon became tied down by superior firepower, but Oates ensured each man continued to fight until the last round was fired, only then ordering them to retreat under the cover of the brush. Despite the Boers repeatedly offering Oates the opportunity to surrender, his command ensured his men did not give in, and ultimately all of his men returned to the column with not one rifle lost to the enemy. However, Oates received a shot to his leg, which broke the bone in his left thigh. After a short period convalescing back in Gestingthorpe, he returned to South Africa until his regiment left for India. It was in India that Oates learned Captain Robert Falcon Scott was recruiting for an expedition to the South Pole. Oates requested to join the expedition, demonstrating that his value to the team lay in his experience with both horse and pack hounds, and that he had recently studied the Tibetan's use of sleds and horses in their mountain villages. He was accepted on the team and was put in charge of the thirty-three dogs and nineteen Manchurian ponies. Oates eventually accompanied the small group of men's ill-fated attempt to become the first to reach the South Pole, suffering from such

Gestingthorpe Hall, the Oates family home. (Gestingthorpe History Group)

Lawrence Oates at Gestingthorpe Hall. (Gestingthorpe History Group)

severe frostbite his limbs could no longer respond to the demands of the return journey. Scott refused to leave Oates behind when requested to do so by Oates, so Oates hoped that he would die in his sleep and no longer be a burden. When he awoke on 17 March 1912, his thirty-second birthday, to a blizzard outside, he left the tent and uttered his final and famous words: 'I am just going outside, I may be some time.' Scott says in his journal Oates' ultimate act of selflessness was 'an act of a brave man and English gentleman'.

Not all gallant actions associated with Essex were carried out by those who served in the armed forces; indeed, many acts of heroism by civilians during the war would go unnoticed. While many may be familiar with Charles Fryatt and his gallant actions during the First World War – his capture, court martial and subsequent execution by the German military in Belgium – many other acts of heroism by civilians in wartime went unnoticed. While some received official recognition from the state through investitures at Buckingham Palace, many received recognition by their employer. The latter would be how Mr James Willian Keeble, Mr Edward Stannard and twenty others would receive the London & North Eastern Railway (LNER) Gallantry Medal for their actions between 1941 and 1947. The LNER Gallantry Medal was instituted in 1941 for the company to recognise outstanding acts of gallantry and resource linked with the railway, but not connected to enemy action. In early 1941 Keeble, the Station Foreman at Manningtree, along with Stannard, a railway ganger, came to the aid of a train on fire that had come to a stop on the bridge at Manningtree, which crosses the River Stour. Approaching a train on fire would be considered a brave act in its own right, but this train's cargo was gunpowder

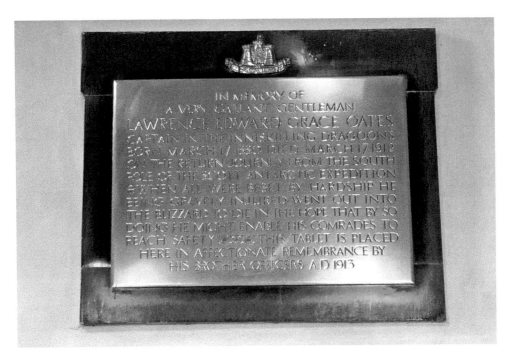

The Oates memorial in St Mary the Virgin Church in Gestingthorpe.

and, as part of Essex's many anti-invasion measures, the bridge itself had been mined with explosives. Given the experience and knowledge of these railway workers, the risk and dangers would have been known to them; however, the pair used fire buckets and water from the river below to keep the flames at bay until help could arrive. The entry for Keeble and Stannard's award of the British Empire Medal, which was only a citation recorded in the *London Gazette*, simply reads, 'For brave conduct in dangerous circumstances.'

The military career of Sir John Hawkwood, born in Sible Hedingham *c.* 1320 to the son of a local tanner, was one of successful and loyal service marred by pillaging and acts that modern historians would deem to be war crimes. Hawkwood enlisted in the English army to fight the French at the beginning of the Hundred Years' War, and supposedly distinguished himself at the battles of Crécy and Poitiers, resulting in him being knighted by Edward III. The temporary peace of 1360 led Hawkwood, like many other English soldiers in France, to join a band of mercenaries. Hawkwood joined the White Company, which he eventually led to become a dominant force in Italy over the course of thirty years. Between 1372 and 1378 the White Company fought for Pisa, Pope Gregory XI, and the Duke of Milan. When not fighting their employers' enemies and awaiting payment for their services, the company would pillage unprotected towns. However, this would not be the worst activity the company would be associated with, which was yet to come and would ultimately lead to Hawkwood becoming known as the 'Butcher of Cesena'. In 1377, acting on the papal legates' orders, the White Company ruthlessly massacred the people of Cesena, who had rebelled against the pope's authority. It is believed that Hawkwood was buried in Florence and later returned to England at the request of Richard II.

Above left: The grave of Captain Fryatt at All Saints Church, Dovercourt.

Above right: The cenotaph to Sir John Hawkwood in St Peter's Church, Sible Hedingham.

Although there are many more people whose association with Essex is worthy of mentioning, the final military personality to be mentioned here is that of Frederick Corbett. Born in Maldon on 17 September 1853, Corbett's birth name was actually David Embleton and his story is one of great success followed by disgrace. In 1873, he enlisted in the King's Royal Rifle Corps under the name Frederick Corbett, and served with the 3rd Battalion during the Egyptian campaign where he was awarded the VC in early 1883 for his bravery when tending to a fallen officer's wounds the previous year at Kafr Dowar. However, from this point it was all downhill for Corbett. He left the army late 1883 and sold his VC and campaign medals, although he re-enlisted into the Royal Artillery in the following year. On 30 July 1884 Corbett was found guilty of being absent without leave, embezzlement, and theft from an officer, and was subsequently stripped of his (now sold) VC and the accompanying annuity. In February 1887, Corbett was once again found guilty of theft and given eighty-four days' hard labour, which would be followed by another eighty-four days in September 1889 for striking an officer. Corbett was finally discharged from the army in January 1891 as medically unfit for service, and died in at the Maldon Union Workhouse on 25 September 1912.

It is fitting place to finish this book with a chapter about the people associated with Essex's military heritage, for it is the people of Essex and their inspiring or intriguing stories that help bring the past to life. Behind the mud, stone, bricks and concrete of every military heritage site in Essex there are countless stories of the people associated with these places waiting to be discovered.



The Combined Military
Services Museum in
Maldon, where Corbett's
Snider Enfield carbine is
displayed. (Combined Military
Services Museum)

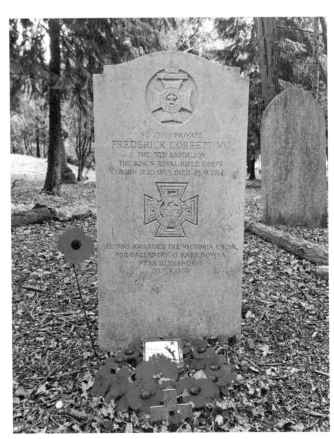

The grave of Frederick Corbett
VC in Maldon Cemetery.

Select Bibliography

Beales, A., *Bures at War: A Hidden History of United States Army Air Force Station 526* (All Things Print, 2019)

Bingley, P., *Hallowed Ground* (Ridgewell Airfield Commemorative Museum)

Bowman, M. W., *US 9th Air Force Bases in Essex, 1943–44* (Pen & Sword, 2010)

Brown, J. G., *The Mighty Men of the 38st: Heroes All* (Publishers Press, 1984)

Burrows, J. W., *The Essex Regiment volumes 1–6* (Essex Territorial Army Association, 1925–37)

Cannon, R., *Historical Record of the Fifty-Sixth, or The West Essex Regiment of Foot: Containing an account of the formation of the Regiment in 1755, and its subsequent services to 1844* (Forgotten Book, 2018)

Carter, T., *Historical Record of the Forty-Fourth, or The East Essex Regiment* (Naval & Military Print, 2015)

Clacton VCR Group, *Defending the Coast: World War Two Defences at Clacton-on-Sea, Holland-on-Sea & Jaywick* (Clacton Victoria Country Group, 2009)

Cooper, J., *A History of the County of Essex: Volume 9, the Borough of Colchester* (Victoria County History, 1994)

Corder-Birch, P. & Corder-Birch, A., *The Works: A History of Rippers Joinery Manufacturers of Castle and Sible Hedingham* (Adrien Corder-Birch, D.L., 2014)

Doyle, Paul. A., *Fields of the First: A History of Aircraft Landing Grounds in Essex Used During the First World War* (Forward Airfield Research Publishing, 1997)

Foakes, S. P. and McKenzie-Bell, M., *Essex Yeomanry: A Short History* (Essex Yeomanry Association, 2012)

Foley, M., *Essex at War From Old Photographs* (Amberley Publishing, 2012)

Matin, T. A., *The Essex Regiment 1929–1950* (The Essex Regiment Association, 1952)

Nock, O. S., *Britain's Railways at War 1939–1945* (Ian Allan Ltd, 1971)

Jarvis, S., *Essex Pride* (Ian Henry Publications, 1984)

Limb, S. and Cordingly, P., *Captain Oates: Soldier and Explorer* (Pen & Sword, 2009)

Osborne, M., *Defending Essex: The Military Landscape from Prehistory to the Present* (The History Press, 2013)

Phillips, A. B., *Steam and the Road to Glory: The Paxman Story* (Harvey Benham Charitable Trust, 2002)

Smith, A., *Braintree and Bocking at War* (Alan Sutton, 1995)

Smith, G., *Essex Airfields in the Second World War* (Countryside Books, 1996)

Smith, J. R., *Pilgrims & Adventurers: Essex (England) and the Making of the United States of America* (Essex Record Office Publications, 1992)

Starr, Christopher, *Medieval Mercenary: John Hawkwood of Essex* (Essex Record Office Publications, 2007)

Summers, A. and Debenham, J., *Battlefield Essex* (Essex Hundred Publications, 2017)

Swieszkowski, J., 'Harwich Steamers in Wartime', *Great Eastern Railway Society Journal* (2019)

The Harwich Society, *The Harwich Redoubt: Built to Defend Harwich Against Napoleon*

The Great Eastern Railway Magazine, bound volumes 1914–21

The London and North Eastern Railway Magazine, bound volumes 1939– 45

Valentine, I., *Station 43: Audley End House and SOE's Polish Section* (Sutton Publishing, 2004)

Vickers, P., *Aldershot's Military Heritage* (Amberley Publishing, 2017)

Willingham, E. P., *From Construction to Destruction: An Authentic History of the Colne Valley and Halstead Railway* (Halstead and District Local History Society, 1989)

Acknowledgements

I hope you have enjoyed this concise journey into Essex's military past, its history and heritage, and I implore you continue to explore the fascinating physical landscape and the remarkable lives of those that represent Essex's diverse military history.

I would like to acknowledge the numerous sources for the stories I have explored, and more importantly thank the many institutions and individuals who provided information and allowed the reproduction of images; their help has been invaluable in completing this publication during a very challenging 2020–21.

For use of images I am grateful to the Chelmsford Museum, Essex Regiment Museum, Brightlingsea Museum, Combined Military Services Museum, Gestingthorpe History Group, Mr Philip Robey, Mr Alan Wicker, Godalming Museum, East Anglian Railway Museum, Ridgewell Commemorative Airfield Museum, and the Harwich Historical Society.

For their invaluable assistance in aiding my research I would like to thank the staff at the Essex Record Office, Major (Retd) Peter Williamson, Dr Mark Courtis, Margaret Stone, Major (Retd) Paul Raison and the Parachute Regiment Association, Mr Paul Bingley, and Mr Mick Chapman.

Finally I would like to thank Amberley Publishing for allowing me the opportunity to write this book, and my wife, Angela, for her support and continued assistance as my unofficial 'editor-in-chief'.